LITTLE BOOK OF

BALENCIAGA

Emmanuelle Dirix is a cultural theorist who specializes in fashion studies. She has over 20 years of lecturing experience at institutions including Central Saint Martins, London College of Fashion and the Royal College of Art, and has been leading historic and contextual studies at the Antwerp Fashion Academy since 2009. She has published widely on fashion in both academic and popular publications. Her most recent book is *Dressing the Decades* (Yale University Press). In addition, she works as a freelance curator and fashion branding and communications consultant for the luxury industry. Recently she has joined the Institute of Global Health Innovation at Imperial College, as a senior teaching fellow.

Published in 2022 by Welbeck
An imprint of Welbeck Non-Fiction Limited,
part of Welbeck Publishing Group.
Based in London and Sydney
www.welbeckpublishing.com

A CIP catalogue record for this book is available from the British Library.

ISBN 978-1-78739-830-6

Printed in China

10 9 8 7 6 5 4 3 2 1

LITTLE BOOK OF

BALENCIAGA

The story of the iconic fashion house

EMMANUELLE DIRIX

WELBECK

CONTENTS

EARLY
YEARS

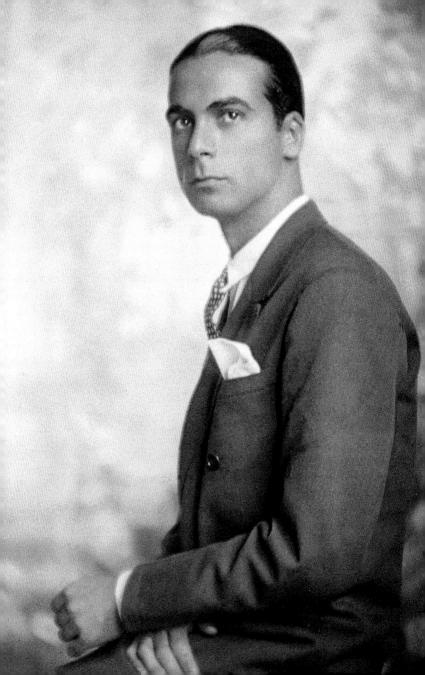

THE YOUNG
VIRTUOSO

Cristóbal Balenciaga was born on 21 January 1895 to a seafaring
father and a seamstress mother in the coastal town of Getaria
in the Basque Country, Northern Spain. He came from a modest
background, but his family were not impecunious by any means,
as some biographies have implied. His father was the local
mayor when Balenciaga was born and a state employee up until
his demise in 1906, skippering boats for the Customs fleet.

After her husband's death, Balenciaga's mother, Martina
Eizaguirre, took sole responsibility for supporting the family
and set up a small workshop where she taught local girls to sew.
In addition, she undertook private sewing commissions, most
importantly for the Marquesa de Casa Torres, who in years to
come would encourage, support and later act as the patron of the
young Balenciaga. The story goes that Balenciaga made his first
garment, a coat for his cat, at the age of six, but became frustrated
as the animal kept running away and moving during "fittings".
Another story, often recounted to illustrate his early interest in
fashion, involves him audaciously asking the Marquesa de Casa
Torres (to whom he had access through his mother) if he could
copy her walking costume. She was apparently so amused by his
request that she agreed and is even said to have worn his version.

OPPOSITE Cristóbal Balenciaga, c.1927

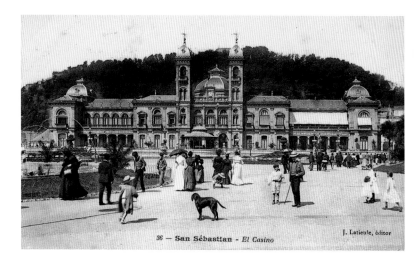

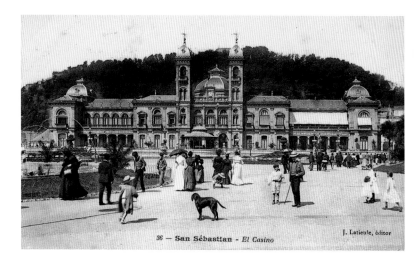

36 — San Sébastian - El Casino

J. Latieule, éditor

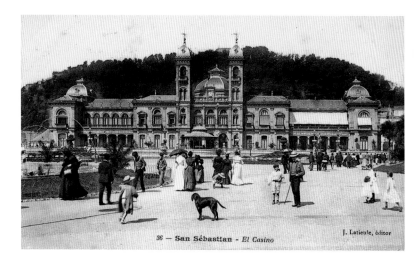ABOVE The Casino, San Sebastián, early twentieth century

The occupation of Balenciaga's mother goes a long way to explain his passion for sewing, and he started on the road to a professional career in tailoring proper at the tender age of 12. Having completed his elementary schooling, he began a tailoring apprenticeship at Casa Gómez in the neighbouring town of San Sebastián. This illustrious establishment was a favourite of the aristocracy (many of whom owned holiday homes in and around San Sebastián). Indeed, Casa Gómez advertised in local newspapers and magazines, calling themselves "the most important tailors, preferred by the distinguished public". After a year the young Balenciaga decided to continue his training at the newly established New England tailor's shop. It was founded by Messrs Romeo, Quemada and Villar, three of the best tailors from Casa Gómez, who were very happy to take on the promising young apprentice at their new business venture.

After completing his apprenticeship, Balenciaga moved to the newly opened San Sebastián branch of the Parisian department store Les Grands Magasins du Louvre, which, like every large

department store, had its own dressmaking salon and sewing ateliers. He started as a tailor in the women's workshop but within two years rose to become the head of the dressmaking department, which was no small achievement given he was only 18 years old. During his time at Les Grands Magazins du Louvre he also experienced the Parisian haute couture industry firsthand. Attending couture "shows", specifically organized for the department store trade, allowed Balenciaga not only to come into contact with the most prominent couture houses, buyers, suppliers and clients of the day, but also provided him with a thorough understanding of the business side of the fashion industry, which would put him in good stead in the years to come.

In 1917 Balenciaga opened his first solo business venture in San Sebastián, under the simple name: C. Balenciaga. He had chosen a most opportune moment to establish himself as a couturier in the region since many aristocrats, wealthy businessmen and members of the *beau monde* had fled to their summer residences and the lavish hotels of San Sebastián and neighbouring Biarritz to sit out the First World War in comfort and style. The region quickly saw a surge in luxury consumption. Not only did these wartime residents widen the market, but they also elicited a fashion shift from Paris to the Basque Country, as many of the couture houses were quick to move their collection presentations from their Parisian houses to the luxurious dining rooms and ballrooms of the region's upmarket hotels. Indeed, Callot Soeurs, Maison Worth, Paquin and Chanel all showed in Spain to a receptive audience. Not only did this shift bolster the business of local couturiers, but also allowed the likes of Balenciaga to attend the wartime shows and so stay abreast of design innovations in Paris. This in turn helped to shape his own designs, and in September 1918 he showed his first collection.

Creating and showing collections required a significant financial investment, so, given his humble background, Balenciaga was forced to find investors to fund his venture. The sisters Benita and Daniela Lizaso, both traders, provided him with the necessary funds. Less than a year later, Balenciaga and the Lizaso sisters established the company Balenciaga y Compañía, which suggests the first collection had been a resounding success. Balenciaga's association with the sisters would last six years, during which time he cemented his reputation for exquisite craftsmanship and indeed as a leading Spanish couturier.

In 1925, after a year spent securing financial backing and sourcing staff, Balenciaga presented his new collection under his full name: "Cristóbal Balenciaga". This attracted the attention of a distinguished clientele, not least Queen María Cristina de Borbón and several other women of the Spanish Royal Family, including her granddaughter the Infanta Isabel Alfonsa. Few of Balenciaga's designs from this period survive, but those that do provide some valuable insights into his design processes. Like most foreign couturiers he travelled twice a year to Paris – then regarded as the epicentre of fashion and taste – to attend the fashion presentations of the leading haute couturiers (Callot Soeurs, Doucet, Paquin, Chéruit and Redfern, to name but a few) and to find out where fashion was going next. He would then build his own collection, combining Parisian models (to stay relevant) and his own creations (often tailored to his established clientele's preferences), all executed meticulously with impeccable cut and great attention to detail. Interestingly, year on year his creative independence grew, almost in parallel to his success.

Two years later, in 1927, he created "Martina Robes et Manteaux" (Martina had been his mother's name) as a second

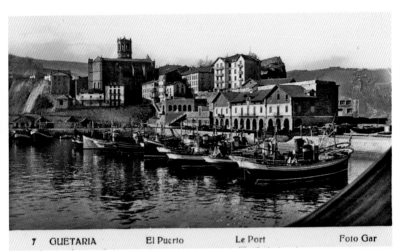

ABOVE The harbour in Getaria, the town of Balenciaga's birth, early twentieth century

brand in a diversification strategy. The brand was soon renamed EISA Costura in another clear link to his beloved mother whose surname was Eizaguirre. This was an ingenious business move that was in many ways well ahead of its time. EISA – unlike his eponymous couture house – offered models in line with the needs and preferences of his local San Sebastián clientele. Customers had a degree of agency and could choose the design and fabrics used, "adjusting" the silhouettes on offer to their personal preference.

While the association with its creator implicitly linked EISA to the world of high fashion and thus made it very desirable, the use of less lavish fabrics reduced the price significantly. As a result, more clients, most importantly the San Sebastián upper middle classes, patronized EISA. This business model resulted in a greater number of garments being sold (albeit at lower cost) and increased returns, which were in turn used to finance the presentation of Balenciaga's biannual couture collections. Balenciaga successfully managed his two businesses from San Sebastián, and while in many ways they worked in tandem (they presented their

collections simultaneously, for example), they always advertised separately in the local media.

However, in spite of a well-polished business strategy, commercial success would soon be hindered by circumstances beyond Balenciaga's control. The proclamation of the Second Republic in Spain, in April 1931, and the subsequent exile of the Royal Family had dramatic consequences for his business. Many of his aristocratic clients, whose patronage was central to his success, were forced to leave, which proved to be a not inconsiderable blow to Balenciaga's business.

Balenciaga, by now a canny businessman as well as a highly accomplished designer, reacted with speed and commercial creativity. In 1932, he requested permission from the city to open a new establishment called B.E. Costura. Given the precarious situation, his new establishment continued the business concept pioneered by EISA Costura, as now more than ever he had to cater for the demands of the local upper middle classes in order to survive financially. It has been called "an emergency solution for an exceptional situation", but once things stabilized he turned these "emergency" measures to his advantage.

In 1933, after a year of simultaneously running EISA Costura and B.E. Costura, Balenciaga consolidated his business and opened a new establishment called EISA B.E. Costura in Madrid. The success of this venture led in turn to the opening of a third couture house in 1935, this time in Barcelona.

Balenciaga managed to keep his fashion businesses operational through innovative business decisions married with exceptional design until 1937. Given Spain's political situation in the 1930s, this was no mean feat. It was in this year, however, undeniably prompted by the outbreak of the Spanish Civil War the previous year, that Balenciaga finally moved his operation to 10 Avenue George V in Paris and so joined the Parisian couture world.

OPPOSITE Balenciaga black lace evening gown, c.1938

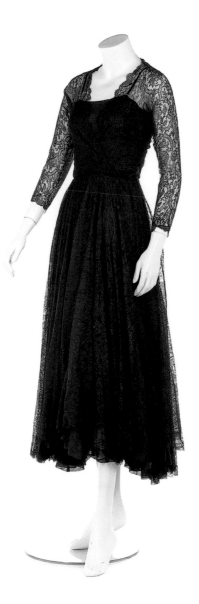

A SPANIARD
IN PARIS

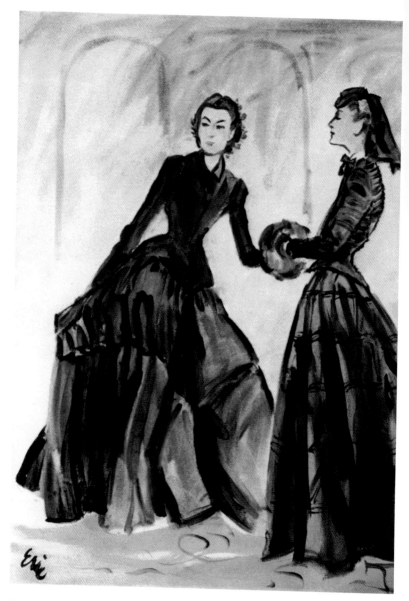

EXILE ON
AVENUE GEORGE V

In July 1936 the Spanish Civil War broke out and once again
brought insecurity and disruption to Spanish life. It has been
suggested that this latest fractious development in a decade
marked by instability was the final straw for Balenciaga. Having
already lost many of his wealthiest patrons after the proclamation
of the Second Spanish Republic in 1931, and the subsequent exile
of the Spanish Royal Family and the Court, he knew what lay in
store and understood implicitly that in the immediate future there
would be little demand for expensive couture in Spain.

Contemporary events combined with his longstanding
connection to haute couture made his 1937 move to Paris
not altogether surprising. On 7 July 1937, Balenciaga founded his
couture house in Paris with his Franco-Polish life partner, Wladzio
Jaworowski d'Attainville, and Nicolás Bizcarrondo, an exile from
San Sebastián, at 10 Avenue George V. Less than two months later,
Balenciaga presented his first Parisian couture collection.

From the moment he opened his Parisian house Balenciaga
received considerable French press coverage and praise. By
December 1937 he received his first mention in *Vogue* and by
the following year they were regularly featuring his designs.
The magazine even dedicated a whole page to his work in

OPPOSITE Balenciaga nineteenth-century style silk velvet dress and
jacket in black and brown (left), *Vogue*, October 1939

their July issue, entitled "French Newcomers", which showed their American readership that he was one of the "new" haute couturiers to watch. Within a year Balenciaga also featured in adverts for Bergdorf Goodman and Marshall Fields & Company who retailed licensed copies of his clothes in New York and Chicago, respectively, indicating his immediate artistic acclaim and commercial success on both sides of the Atlantic.

In his first few years in Paris Balenciaga was often referred to by the press as "the Spanish designer", and his Spanish-ness was often regarded as central to his designs. In October 1938, *Harper's Bazaar* said that his whole first collection had "a flavour of Spain", while in September 1939, *Women's Journal* declared: "His beautiful clothes have the warm colourful drama of his country."

While much of Balenciaga's oeuvre is indebted to his Spanish roots and many of his designs feature Spanish influences (as later chapters in this book will show), it is interesting to note that many of the early parallels drawn by the press were often more to do with a focus on his nationality as a novelty – he was the only Spanish designer in Paris – than on genuine, indisputable Spanish influences. More accurately, Balenciaga's use of historic references in his designs was often related to Spanish costume and/or the work of the seventeenth-century Spanish artist Diego Velázquez. He did propose some overtly Spanish garments in the late 1930s – most famously his 1939 "Infanta" dress – but it is, in fact, his post-war output that features the most explicit Spanish references.

Often, when Balenciaga's work was referred to as Spanish, perhaps the press were really saying that his designs were restrained, modest or demure, features that were often incorrectly conflated with Spanish Catholicism. In 1939 alone, *Vogue* described his creations as "modest" on at least four separate occasions, despite being no more or less so than many other designs featured alongside them. This confusion between the historic and

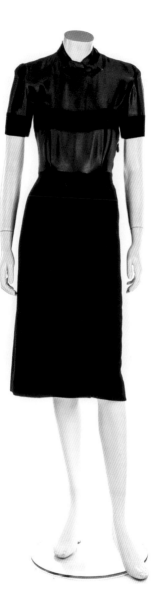

RIGHT Balenciaga
couture black wool
and satin dinner dress,
possibly from his first
Parisian collection,
c.1937

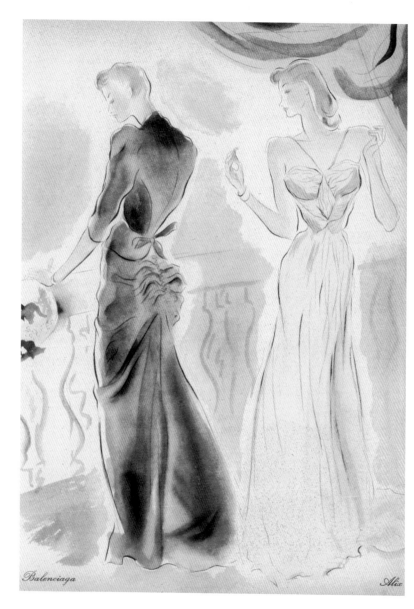

Balenciaga

Alix

Spanish-ness meant that these "identifying" elements of his work as Spanish not only made for easy journalism but all too often became conflated with the "unmodern".

It's true that much of Balenciaga's early Parisian evening wear referenced historic styles, but so did that of his contemporaries. In fact, the final years of the 1930s are marked by historicism in high fashion – most likely driven by a collective romantic nostalgia for better, safer days in a Europe that was once again on the brink of war. So, Balenciaga's adoption or reworking of older styles was actually more about fashion than it was about national identity. When viewed in isolation his use, for example, of white lace during this period could easily be ascribed to his heritage. However, this would be a truism and ignores the popularity of white lace and its abundant use in couture creations at the time.

It might be more useful to focus on how fashion publications often drew attention to the fact that Balenciaga's use of historic references was more innovative than many of his contemporaries. More than once he was credited with "re-introducing" old new elements, such as exaggerated 1850s triangular yokes, an eighteenth-century reticule dress or a "wedding dress that's as demure as a Mid-Victorian's". His use of, or playfulness with, history was often found in innovative details and interpretations, an approach praised at the time and one that would mature and become emblematic of his post-war work.

A link that was repeatedly made in the late 1930s was to the artist Velázquez. As we will see in later chapters, Balenciaga was heavily influenced by his work, but once again these aesthetic links became much more explicit in the years to come. The reason why Velázquez (and less often Francisco Goya) are repeatedly cited when discussing Balenciaga's output during this period was, in fact, down to the staging of the 1939 exhibition of Spanish art that took place in Geneva, Switzerland, which was extensively

OPPOSITE Balenciaga brown evening gown with bustle (left), *Vértice*, May 1939

covered in the same upmarket fashion publications that made those links to Velázquez. As *Vogue* noted in September 1939: "Perhaps this exhibition is what Balenciaga was waiting for, dreaming of. His Spanish mind was quick to respond to the dignity and beauty of Velázquez canvasses: the elaborate fabrics, covered arms, tiny waists, broad head-dresses…"

Fashion has, in fact, always liked to compare itself to art as a means of raising its status, and the comment in *Vogue* was just one example of this. In the same issue a caption accompanying one of Balenciaga's low-backed evening dresses reads: "Balenciaga borrows again from the earlier Spaniard – there's a Velázquez look about this dress which Mona Marie wears like a sixteenth-century [sic] court beauty." This clearly shows that the copy-writer was not familiar with the Spanish aristocracy, their wardrobe nor indeed with Velázquez's work. In the July 1939 issue of *Vogue* a caption accompanying an illustration of a pink satin evening gown makes an equally tentative link: "Balenciaga…draws on Goya's richness of fabric and colour, and round-hipped, tiny-waisted court belles" – this is misleading to say the least given Goya's rare use of the colour pink. Similarly, an illustration of the Balenciaga "Velázquez hat" made of violet felt flanked with fox tails, which featured in the September 1939 issue, is not immediately reminiscent of anything worn at the seventeenth-century Spanish court.

This focus on Spanish references, and especially on Velázquez, can easily overshadow the diversity of Balenciaga's actual output and, indeed, the rich and wide historic costume he drew on as sources in his early Parisian years. His range extends to 1860s-style wedding dresses, eighteenth-century evening coats, tightly fitted Polonaise gowns from the 1880s, seventeenth-century lace collars straight out of a Flemish painting, and nineteenth-century bustles and panniers. As *Vogue* commented in March 1939: "Balenciaga tops chiffon skirts with basket-like hip drapery of satin or taffeta,

OPPOSITE Balenciaga "Andalusian Dancer" dress with black ottoman silk bodice and a three-tiered Spanish lace skirt (right). *The Sketch*, June 1939

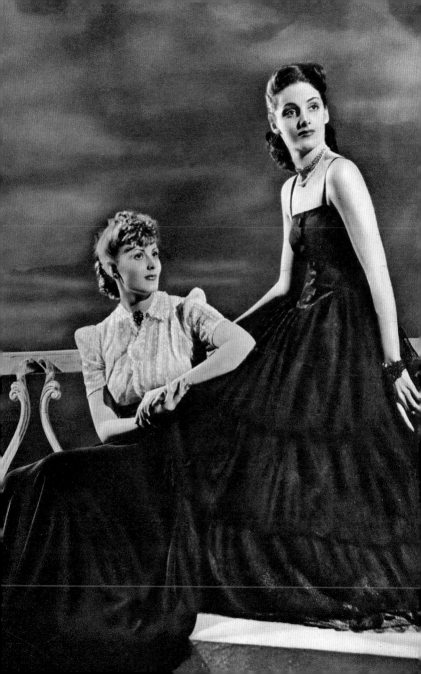

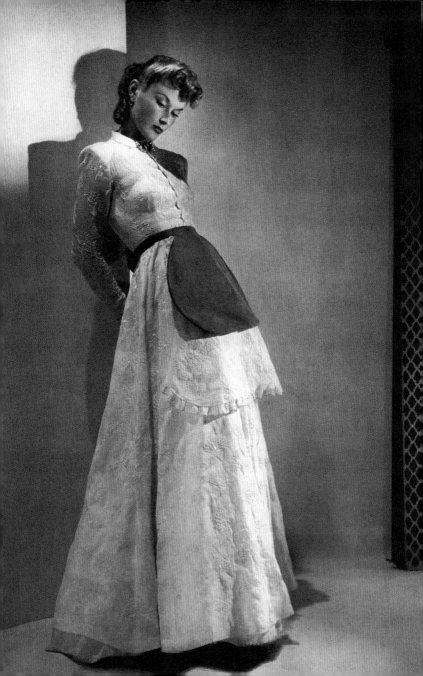

OPPOSITE Balenciaga
embroidered
handkerchief linen
dress with two
aprons, *Vogue*, 1939

RIGHT Balenciaga
red broadcloth coat
with dolman sleeves
and corseted bodice,
Vogue, June 1939

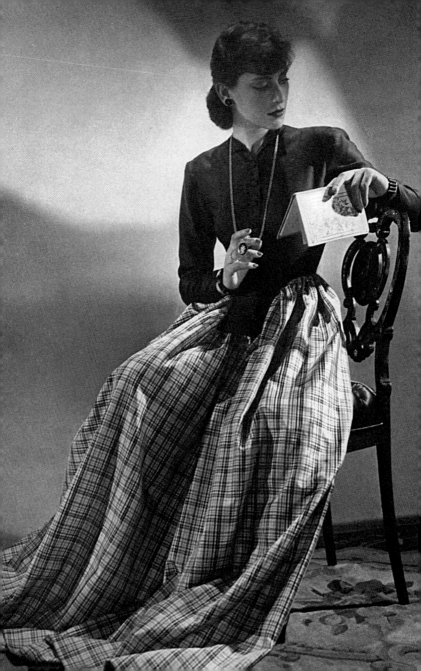

very Vigée Lebrun." Balenciaga's designs were all reinterpreted in such a way that they were both historic and modern, and they are evidence of their creator's extensive and in-depth knowledge and understanding of costume and art history.

Yet while Balenciaga's evening wear and occasion dresses were exquisite examples of the historicist and escapist tendencies that dominated fashion design in the late 1930s, his daywear was also a clear product of its period. It was typified by elegant practicality and versatility, and also combined a good dose of realism about what was to come with its innovative pattern cutting and draping. His calf-length day dresses and suits with peplums, his pleated skirts and exquisitely tailored, moulded jackets were particularly coveted by the press, and this marks the point at which his designs started to be described as sculptural, a term that would sum up many of his silhouettes in the 1950s and demonstrate his evolution in fashion.

While Balenciaga's Parisian business enjoyed considerable success and his move had clearly paid off, he longed for home. He kept a close eye on the situation in Spain, waiting for the right moment to restart his involvement with the three establishments that he had been forced to leave behind. He had asked his staff in Spain to keep all the fashion houses open, but what he really wanted was to be closely involved with the creation of collections once more. In 1938, he changed the name of his San Sebastián establishment back to its original name of EISA, and once the other two establishments were able to resume normal activity, they too adopted it. From 1942 until his retirement in 1968 Balenciaga was once again closely involved with EISA and supervised its collections – and in doing so maintained close links with his country of birth.

For now, though, his Spanish establishments were soon to become his only available fashion "link" to the rest of the world.

OPPOSITE Balenciaga plaid surah skirted dress and navy surah jacket, *Vogue*, March 1939

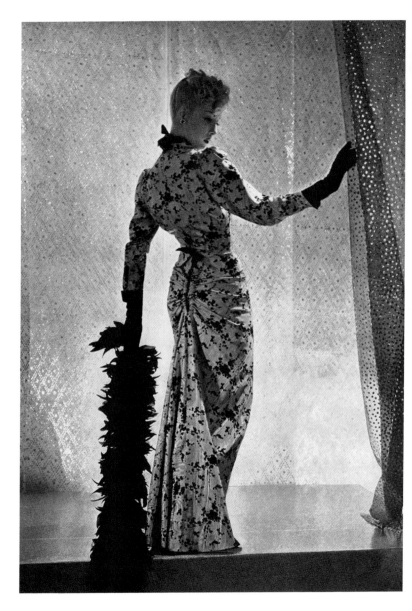

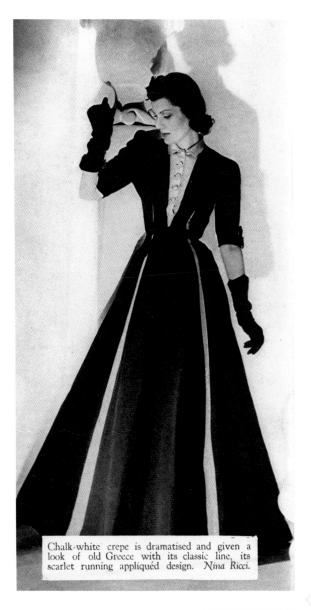

OPPOSITE Balenciaga pale blue printed moire Polonaise dress, *Vogue*, April 1939

RIGHT Balenciaga dinner dress of black faille, highlighted with pink and tied-bow waist, *Britannia and Eve*, August 1939. The dress is incorrectly captioned as being by Nina Ricci

Chalk-white crepe is dramatised and given a look of old Greece with its classic line, its scarlet running appliquéd design. *Nina Ricci.*

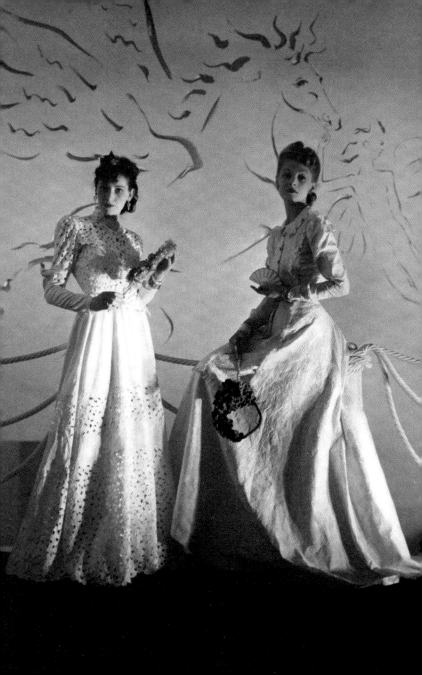

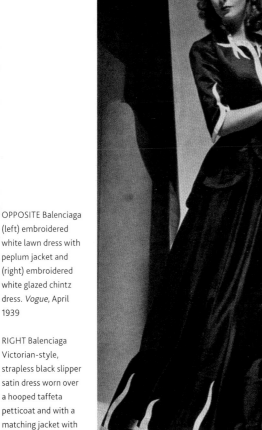

OPPOSITE Balenciaga (left) embroidered white lawn dress with peplum jacket and (right) embroidered white glazed chintz dress. *Vogue*, April 1939

RIGHT Balenciaga Victorian-style, strapless black slipper satin dress worn over a hooped taffeta petticoat and with a matching jacket with a petalled basque. *The Sphere*, December 1938

THE WAR
YEARS

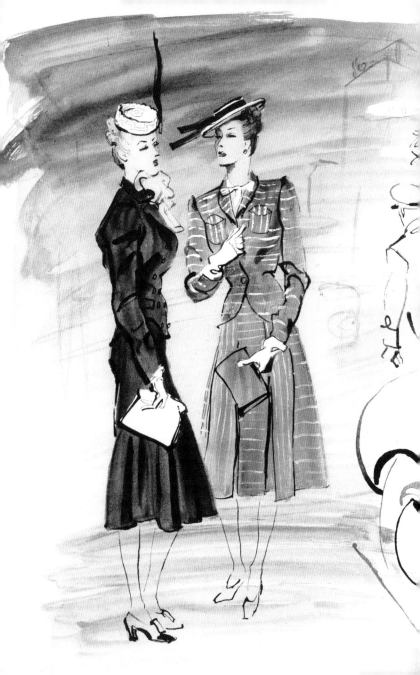

PRACTICAL LUXURY

Germany's invasion of Poland on 1 September 1939 came as no great surprise. Most European powers had been quietly preparing for war since the late 1930s, while nevertheless hoping that another major conflict on European soil could be avoided. This misplaced hope, combined with a good dose of realism, was reflected in the Autumn collections that were shown only days earlier: daywear was characterized by increasing practicality whereas evening wear was romantic, escapist and historicist in nature.

Piguet showed a reversible, wool "air-raid" outfit, the cape of which doubled as a blanket; Hermès presented versatile, plaid hooded capes and all manner of practical bags; Creed an "Alerte Plaid" blanket that could be worn as a cape or overskirt; Schiaparelli featured a one-piece zippered jumpsuit (available in blue or shocking pink); and Lanvin made her own tweed gas-mask case decorated with silver studs. Chic pyjamas by Molyneux were suitable for use in both the home and air-raid shelter, while at Lanvin there were practical day dresses. Box coats, an abundance of fur, knitwear and hooded jersey dresses for keeping warm also featured in most collections, and all this was mixed with a good degree of patriotism and militarism. Colours such as aeroplane

OPPOSITE Balenciaga grey and white sheer wool suit (right), *Vogue*, April 1939

grey and French soil beige were used to create military-style jackets and even scarves printed with French regimental flags became de rigueur. *Harper's Bazaar* summed up the mood: "The French have decreed that fashion shall go on…everyone makes an effort to be as elegant as possible."

As few items from this period survive, we are mostly reliant on their representation in magazines to establish what designers were doing. Interestingly, Balenciaga does not appear to have produced "special" wartime or bomb shelter items, and is never mentioned in articles that discussed these wartime sartorial "inventions". Arguably, this is reflective of both his clientele and his temperament, which was never suited to novelty. His designs were, however, still regularly featured in fashion publications and his daywear in particular was both a continuation of the increasing practicality suggested throughout the second part of the decade and in line with the rationality and practicality permeating all couture collections. Expertly tailored day ensembles and dresses, often combining masculine elements with more romantic detailing, in dark-coloured wool and velvet became his signature styles, and were often praised by the fashion press as "triumphantly wearable".

Upon the declaration of war several couture houses temporarily shut their doors, and eligible heads of houses reported for military duty; Balenciaga was exempt owing to his age and because he was a foreign national. Very quickly, though, special dispensations were granted to couturiers, so they could reopen and return to work: fashion was after all of vital importance to the French economy. In October 1939 *Vogue* was reporting how Parisian life was getting back to normal and how most salons had reopened and were busy preparing for the new collections. These 1940 Spring collections would become known as "Les Collections des Permissionaires", the name derived from

RIGHT Balenciaga
printed silk crepe
summer suit, c.1940

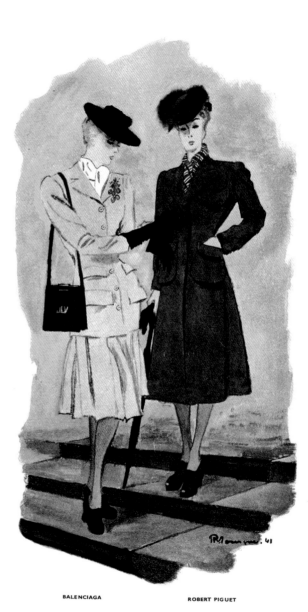

BALENCIAGA

ROBERT PIGUET

LEFT Balenciaga suit
in grey with double
flat pockets (left).
Accessorized with a
bag, gloves, hat and a
white satin scarf, 1941

OPPOSITE Balenciaga
lace, butterfly print,
white silk crepe
evening dress, *Vogue*,
April 1940

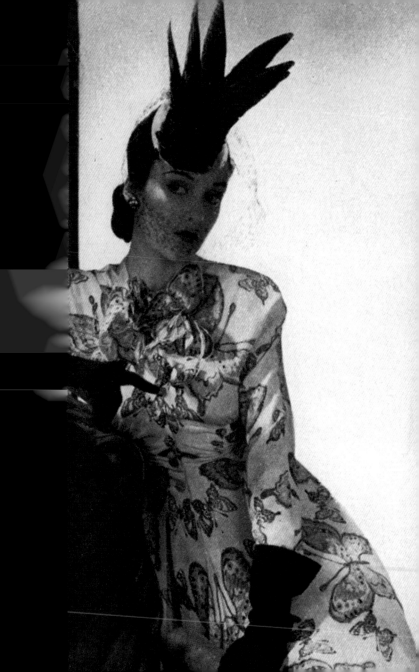

the aforementioned special permission granted to couturiers.

During the spring of 1940 France was engaged in the "phoney war" and while no actual fighting was yet taking place on French soil, the impact of the war was clearly noticeable in the Spring collections. The first collections shown after war was declared swung in favour of realism: increasingly practical, warm and versatile fashions were presented, especially for the domestic market. Luxury was still a feature of evening wear, but even luxury became pragmatic with long-sleeved gowns to keep out night chills in the event of an unexpected trip to the bomb shelter during a night out. Several Balenciaga evening dresses in this style were featured in both French and international fashion magazines and whereas they had previously been called "modest", they were now described as "practical luxury" and "versatile", which only goes to show how context is everything. Evening wear was still very much in the historicist style, and Balenciaga's offerings featured 1880s fitted cuts with bustle draping, large bustle bows and sashes, as well as exaggerated 1860s silhouettes with full skirts topped with bolero jackets.

On the morning of 14 June 1940 the first German troops entered and occupied Paris: the northern half of France was now under German administration. They entered a city that had shut up shop: theatres, cafés, restaurants and the couture salons were all closed for business; some were even boarded up. Many who were able had already fled the capital and one contemporary observer noted that these "refugees" were so overdressed it was as if they were attending a garden party rather than fleeing a war. Within days, however, many couture salons, including Balenciaga, reopened for business, not least to avoid having their business assets seized by the occupier. Balenciaga was no stranger to extreme situations and was probably better equipped than most for adjusting to the new regime in the city.

OPPOSITE Balenciaga blue crepe dress with pendant-sequinned bodice (left), *Vogue*, April 1940

The German occupation meant that France's borders were now closed, and crossing from the Northern occupied area into the unoccupied Southern zone was exceptionally difficult. With the country in turmoil, and with a lack of communications, the rest of the world assumed Paris had wound down its fashion operation. International *Vogue* closed its offices, which were located in Paris, and very little reporting emerged from the city after June 1940. In January 1941, *Vogue* ran one article entitled "Germans over Paris" written by an anonymous "eye witness" who detailed life in the occupied city. Of fashion she observed: "Many of the Paris dressmaking houses are open – Lanvin, Balenciaga, Molyneux, Patou… the collections are shown at 3 in the afternoon, and consist of wearable clothes – wearable clothes for an undertoned life. No real evening dresses…those simple woollen day dresses so rightly inspired by present circumstances, yet so varied, so beautifully made…The new fashions are real, that is why they are so good. They have carefully discarded any abstract, silly, or false proposition."

These remarks regarding the absence of evening wear were not completely correct. The entire war couture output continued to feature extravagant evening wear, albeit fewer models, but there are ample examples, including Balenciaga designs, that show it did not disappear entirely. In fact, an article in the *Tampa Bay Times* on 27 April 1941 describes evening gowns from Paris, including Balenciaga's, as "magnificent and of extreme elegance". Equally, daywear was hardly understated, especially when compared with what other nations were wearing. Balenciaga's day ensembles were often featured in French fashion publications and were a tour de force of his design skills, as he time and again reinvented the simple black day dress. His jackets and coats showed innovative cutting and tailoring and exuded a timeless luxury.

OPPOSITE Balenciaga black crepe afternoon dress with white dots (second from right), 1941

Schiaparelli

Balenciaga

Balenciaga

QU'ELLE a
de charme et
c'hic dans sa sim-
ependant de lui
son originalité.

de diago-
rage. Am-
e donnée
es. Cein-
le dos.

PARCE QUE ce tailleur
peut être porté du matin
au soir, il s'adapte bien à
la vie actuelle et sa ligne
fait une jolie silhouette.

Tailleur fermé à l'aide
d'anneaux de nacre blan-
che. Blouse de soie blan-
che. Nœud de taffetas
et casquette violets.

PARCE QUE cette robe
heureu être portée à partir
de midi jusqu'à minuit
et quelque très élégante
ne soit pas trop habillée.

Robe d'après-midi en
crêpe noir à pois blancs.
L'ampleur est donnée
devant par des bouillon-
nés. Corsage-chemisier.

PARCE QUE l'empièce-
ment du corsage de cette
robe fait très jeune. Elle
est facile à porter et per-
met de sortir en ville l'été.

Robe de crêpe de Chine
noir. La jupe est coupée
en biais, le corsage mon-
té à petites fronces par-
tant d'un empiécement.

BALENCIAGA

ROBERT PIGUET

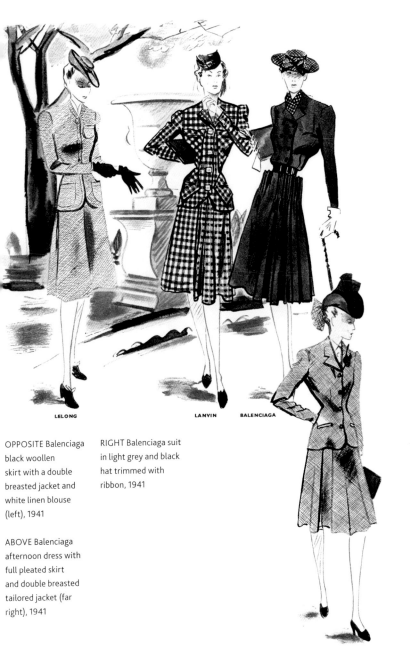

LELONG

LANVIN

BALENCIAGA

OPPOSITE Balenciaga black woollen skirt with a double breasted jacket and white linen blouse (left), 1941

ABOVE Balenciaga afternoon dress with full pleated skirt and double breasted tailored jacket (far right), 1941

RIGHT Balenciaga suit in light grey and black hat trimmed with ribbon, 1941

While Balenciaga's designs were in line with the fashions his contemporaries were producing, in the sense that they were original but not radically different, it is worth noting that one of his dress designs from 1943, black with a fitted body but very voluminous long sleeves, was picked up by the French fashion press and described as "Très Nouvelles". Not only was this dress radically different from the rest of the silhouettes featured, but Balenciaga's play with form could also be regarded as an early example of his sartorial experiments with shape and volume which would come to define the later years of his career.

The same year also saw the first veritable incarnations of what would become another staple of his work: the matador jacket. This explicit Spanish reference to the traditional bullfighting costume can be explained in a variety of ways. Since the late 1930s there had been an increased interest in "regional" costume and many designers had incorporated elements from these traditional outfits in their fashions. This, paired with a revival in nationalism and regionalism, which was encouraged by many European nations during the war, might explain its appearance. Another more personal reason could be that the uncertainty of war elicited a nostalgic need in Balenciaga for a closer connection with his home nation. However, it could simply be that Balenciaga recognized the similarities in cut between the fashionable bolero of the early 1940s and the matador jacket, and hence embellishing the former to resemble the latter represented only a small leap in design. Regardless of the reason, we will see in later chapters that these matador jackets became a classic post-war Balenciaga item.

Until the Liberation of France, beginning in September 1944, the rest of the world had very little knowledge of what many of the couturiers of Paris were doing, though there were a few exceptions, and Balenciaga was one of them. Due to his Spanish

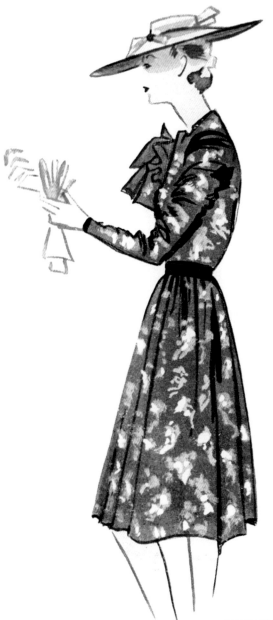

RIGHT Balenciaga
white and beige
printed dress, with a
brown belt and white
straw hat,1941

nationality and Spain's neutrality in the war, he was able to travel back and forth between Paris and San Sebastián and so keep his Spanish EISA establishments open. It was through these that his work was able to travel to New York in the summer of 1941 to be included in a show of Spanish fashion designers. In July 1941, *Vogue* reported on the show and made the very astute observation that "almost the only Continental designers still free to express themselves are the Spanish modistas". The article included five illustrations of Balenciaga silhouettes, one an historically styled evening gown with a nipped-in waist, exaggerated hips and a fitted beaded redingote jacket and day ensembles with bustle pleat skirts and innovatively cut jackets. This international loophole also meant he was able to maintain his ties with American and Italian hat and footwear companies who advertised Balenciaga models throughout the war.

The first post-liberation *Vogue* report from Paris in October 1944 featured a Balenciaga deep amber, wool tailored coat, alongside designs by Lanvin and Mad Carpentier. Balenciaga's first post-Liberation collection was described by *The Province* newspaper on 9 December 1944 as "Spanish" and "not...very interesting, there being a monotonous sameness". The article complained in particular about the plain day dresses, the sombre colours and dull fabric choices. This "dulling" down was more about politics than design: upon its liberation, the world had been shocked to discover just how extravagant Paris couture had been throughout the war, especially when compared to countries that had endured strict rationing and governmental interference in fashion production. To heal their damaged reputations and to make their work internationally saleable, Parisian couturiers, including Balenciaga, deliberately toned down their 1944 collections. For now, Balenciaga's work still followed and complemented that of his contemporaries, but that was soon set to change.

OPPOSITE
EISA red and white shirt-waister style cotton summer dress, c.1944

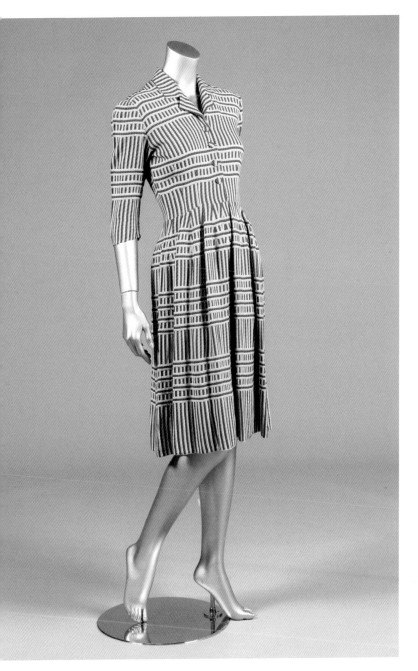

DESIGN
INFLUENCES

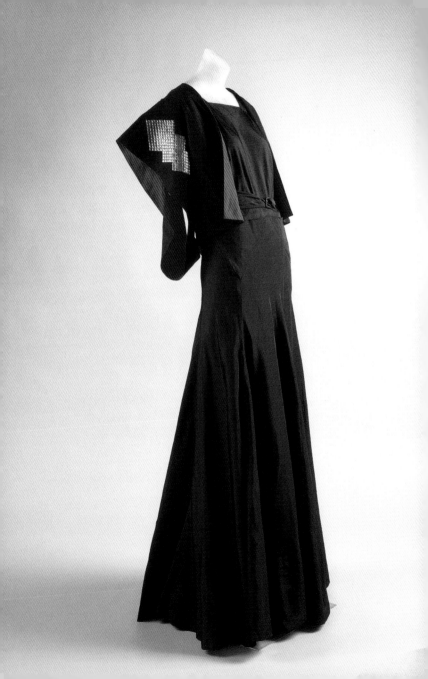

SOURCES OF INSPIRATION

To understand designers that are hailed as innovators or game changers, it is important not only to place them within their time frame and compare their work with that of their contemporaries, but also to consider those who paved the way for their radical sartorial experiments, who directly or indirectly influenced their design development, and who shaped both their aesthetics and/or design ethos.

The romantic notion that "pioneers" of fashion are genius mavericks is an attractive one, but it is essential to stress that they do not operate in an ivory tower and that their ideas, however "original" they may seem, have more often than not been shaped by the reinterpretation of both design concepts and cutting and sewing techniques which have been around for decades, if not centuries. Equally, for such innovations to occur, take root and make a genuine impact, one cannot ignore the need for the right sociopolitical time frame.

Balenciaga was a great innovator and created some truly original silhouettes. He experimented with cutting and tailoring techniques, and introduced several new fashions into

OPPOSITE Lanvin Kimono-style ensemble with Japanese-inspired embellishment, c.1934

the mainstream, but it would be an oversight to ignore the designers who he himself admired and, indeed, cited as his own sources of inspiration.

This book has set out to emphasize that Balenciaga's truly original work, which constituted a radical departure from his peers, did not start until the post-war period. However, many of those who inspired and preceded him in taking an alternative path to that of the mainstream pre-date this time. Equally, while it is his post-war work that is mostly regarded as truly different, the ideas that were fundamental to these strikingly original silhouettes – namely, his treatment of the female body and his belief that fashion should not impede it – had been part of his work for much longer. Balenciaga's emphasis on the freedom of the female body is not altogether surprising, as his training as a designer coincided with important developments in fashion in the 1920s and '30s, not least the reconceptualization of the female body, the emergence of the New Woman, the new relationship between comfort and luxury, and indeed the liberation of the female form.

During his apprentice years Balenciaga was able to attend couture presentations, firstly in the resorts of Biarritz and San Sebastián. Later, while working at Les Grands Magasins du Louvre, he would travel to Paris to visit the trade couture shows since he was responsible for selecting and buying models that the department stores would interpret. As a result, although Balenciaga was not located in Paris, his knowledge of contemporary haute couture was up to date and extensive. Even after he opened his own establishment in San Sebastián, he continued to travel to Paris and attend the shows of his favourite couturiers, and he would incorporate their designs in his collections. Like many of

OPPOSITE Illustration from *Les Soieries Illustrées*, a fashion brochure for Parisian department store A Pygmalion, featuring a selection of ladies elegant house coats with kimono-style sleeves, Paris, 1909

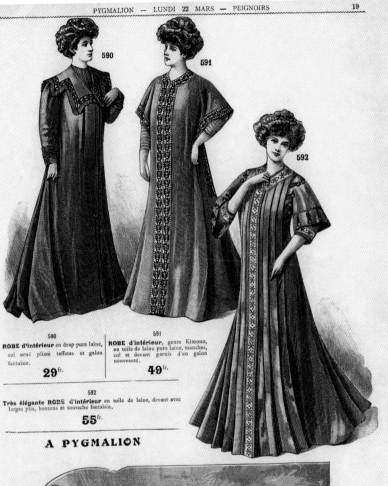

590
ROBE d'intérieur en drap pure laine, col orné plissé taffetas et galon fantaisie.

29fr.

591
ROBE d'intérieur, genre Kimono, en toile de laine pure laine, manches, col et devant garnis d'un galon nouveauté.

49fr.

592
Très élégante ROBE d'intérieur en toile de laine, devant avec larges plis, boutons et soutache fantaisie.

55fr.

A PYGMALION

FIVE O'CLOCK TEA

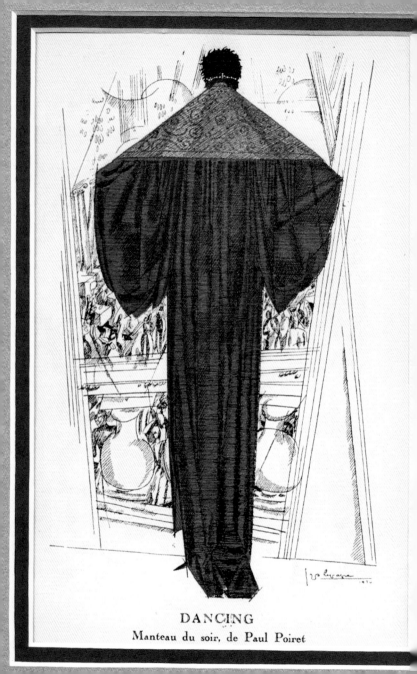

DANCING

Manteau du soir, de Paul Poiret

his contemporaries, Balenciaga attended a wide variety of couture shows and took inspiration from a cross-section, but the designers he most admired, and whose work he interpreted in his own collections, were female – specifically, Coco Chanel, Madeleine Vionnet, Louise Boulanger, Jeanne Lanvin and the Callot Soeurs.

All these designers were involved in redefining the fashionable female form. They were especially interested in liberating the female body from restrictive under- and outer garments. Their innovative pattern cutting was a great inspiration for Balenciaga and while his post-war work might not aesthetically resemble the work of these women, the ethos embodied by their oeuvre did.

The Callot Soeurs and Vionnet were particularly knowledgeable about non-Western patterns and techniques – including Arabic Moorish cutting, ancient Greek pleating and folding, and, possibly most influential of all, the Japanese kimono – and they incorporated and interpreted these extensively in their designs. Indeed, the T-shaped kimono (and the vogue for Japonisme) was instrumental in modernizing the fashionable wardrobe of the early twentieth century. Its shape was interpreted by all the most progressive haute couturiers of the time – Poiret, Paquin, Lanvin, Beer, Fortuny, Vionnet and Callot Soeurs – and it was instrumental in defining the flat silhouette of the early 1920s.

Balenciaga proposed his own interpretations of the kimono, albeit several decades later, and its influence can be discerned in several of his most innovative shapes: his 1947 barrel line and later his 1955 tunic silhouette, for example, were clearly indebted to the T-shape of the kimono. Its influence did not end there. Indeed, his cocoon coats featured the kimono's arched back; from 1939 onwards, he

OPPOSITE Paul Poiret "Dancing" evening coat illustrated by Georges Lepape, *La Gazette du Bon Ton*, 1920

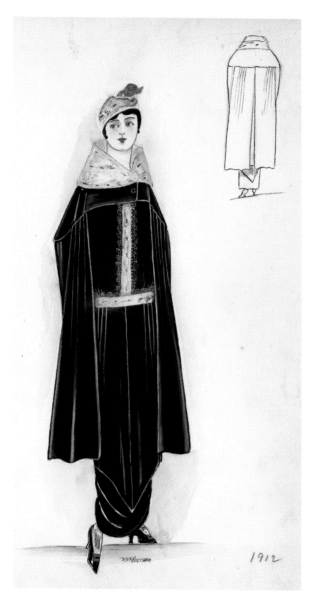

1912

LEFT Callot Soeurs
black day dress with
matching cape, 1912

OPPOSITE
Mainbocher dresses
with Japanese
influences, *Vogue*,
1934

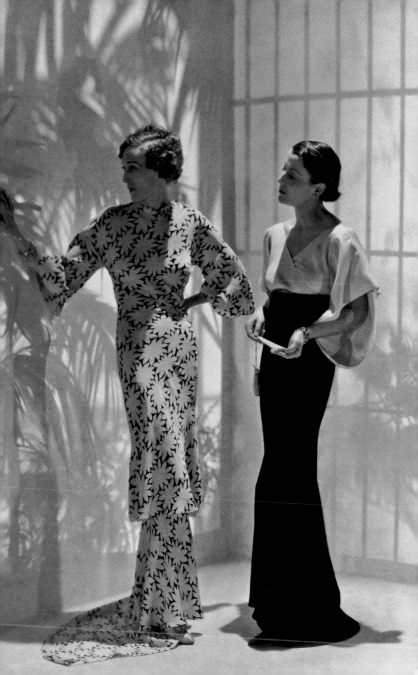

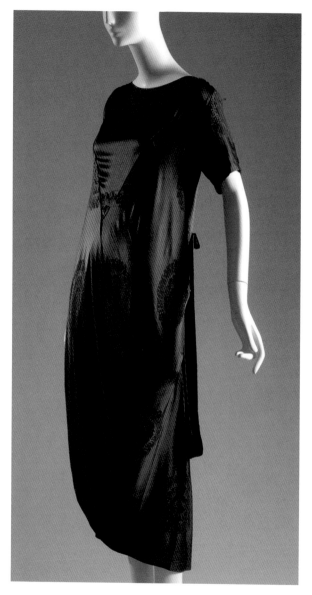

LEFT Callot Soeurs silk jacquard afternoon dress, c.1917

OPPOSITE Paul Poiret "Sorbet" evening dress in silk satin and chiffon with glass beads

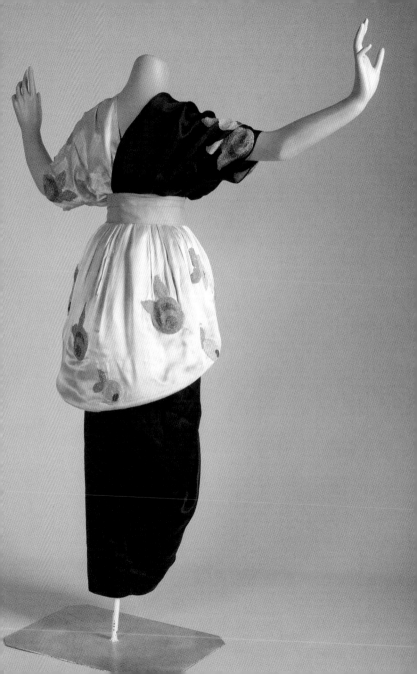

repeatedly interpreted kimono sleeves; his asymmetrical hems were shorter at the front than the back; and his haneri-like collars falling back to reveal the nape are all features of this traditional garment. Moreover, the way in which Balenciaga played with folds and volume, as in his spectacular 1967 chou wrap, referenced both the kimono and the early-twentieth-century designers who had championed Japonisme and incorporated it into their collections.

Thus, Japonisme and the kimono were arguably fundamental to Balenciaga's post-war work, but the other non-Western influences in his work, such as Moorish dress and Indian wrapping garments, should not be overlooked: their play with volume might not have translated literally into his creations, but the approach and relationship to space and the body suggested by them were a constant in his career. It should be noted, however, that Balenciaga's own design relationship with volume evolved significantly throughout his Parisian years, in yet another example of how he loved to take his time to develop and explore ideas at his own pace so he could test their limits. It could be contended that his Velázquez dresses of the late 1930s represented his first foray into experimentation with volume; that his voluminous silhouettes of the 1950s had a weightlessness, were more exaggerated and experimental, and moved away from their literal references; and that his designs during the 1960s arguably approached volume in an even more conceptual and rigid manner. So, although these periods have a clear aesthetic identity, the underlying idea remained the same: an exploration of the relationship between the body and space, influenced by history and multiple cultures.

OPPOSITE *Girl in a White Kimono* by George Hendrik Breitner, 1894

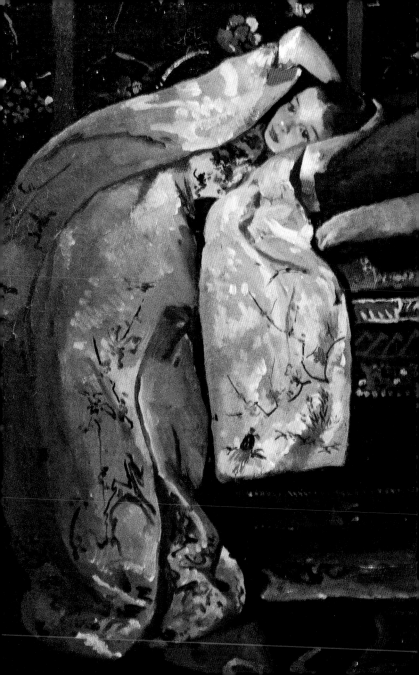

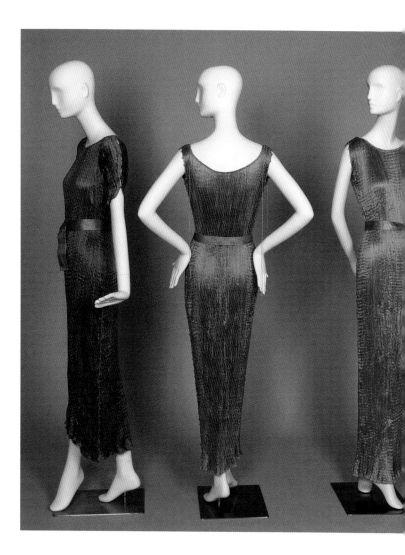

ABOVE Mariano Fortuny, pleated silk "Delphos"
dresses, c.1930s–1940s

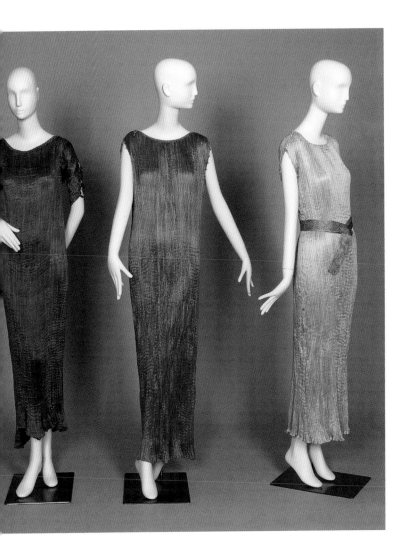

THE ROAD TO ABSTRACTION

PLAYFUL INNOVATION

Balenciaga's best-known pieces of work – and indeed the part of his oeuvre that has seen him referred to as a "great Modernist", the "high priest of haute couture" (*The Jewish Chronicle*, 1964), the "Shape master" (*Los Angeles Times*, 1957) and the "only true couturier" – are the designs he started producing after the Second World War.

Over the next two decades he would slowly pare down his designs and strip away all superfluous detailing to achieve his iconic, sculptural, quasi-architectural and at times austere shapes of the 1960s. It is useful to trace his aesthetic development because it reveals the master's modus operandi: a near-obsessive perfecting of ideas through the meticulous exploration of their possibilities and limits.

Although there had been hints in his earlier work of things to come and how his aesthetic might evolve, it was Balenciaga's desire to offer an alternative to the dominant post-war silhouette that saw him move in a different direction to "the mainstream" by playing innovatively with shape, line and volume. What supported or lay at the base of these sartorial innovations was a profoundly different design approach to, and relationship with, the female body compared with that of his contemporaries.

OPPOSITE Balenciaga unfitted coat, 1947

The year 1947 witnessed the fashion bomb that was Dior's "New Look", which in many ways was the culmination of where Parisian fashion had been heading since 1939. It combined an 1850s rounded silhouette, full skirt and nipped-in waist to create the perfect hourglass shape. The word "create" is consciously used here, as Dior's garments necessitated a return to structuring undergarments and/or garment integral boning. For many, this full and luxurious silhouette marked a return to luxury and normality, although many others considered it regressive and outdated. Regardless of its detractors, this ultra-feminine line very quickly became the dominant post-war fashionable shape.

Dior was far from being the only couturier to put forward this vision of femininity. Several of his contemporary male colleagues – most notably Jacques Fath and Pierre Balmain – also took a sartorial approach which suggested through its structure that female bodies needed moulding and shaping, thus implying that the female body is flawed or lacking in some way and in need of enhancing.

Instead of wanting to restrict and accentuate the female body (and shackle it within the confines of an ideal shape), Balenciaga went the other way and started to play around with the space that exists between the body and the garment. In doing so, he started altering natural shapes and proportions rather than binding them into place. He preferred garments to move naturally with the body rather than restricting it and forcing unnatural movement.

While Dior was turning women into upside-down flowers, Balenciaga presented his cocoon coat, which had volume at the back and no defined waist, its rounded cutting presenting soft, sloping shapes and curves that only touched the body at the hem. It became an immediate success, hailed by the fashion press for its wearability, and was quickly copied by ready-to-wear

OPPOSITE Balenciaga striped wool coat, 1950

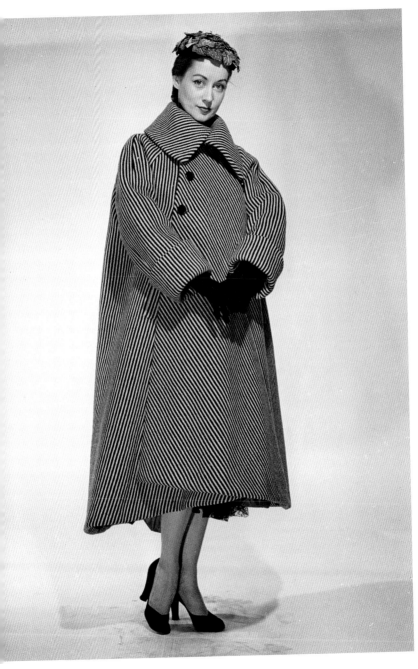

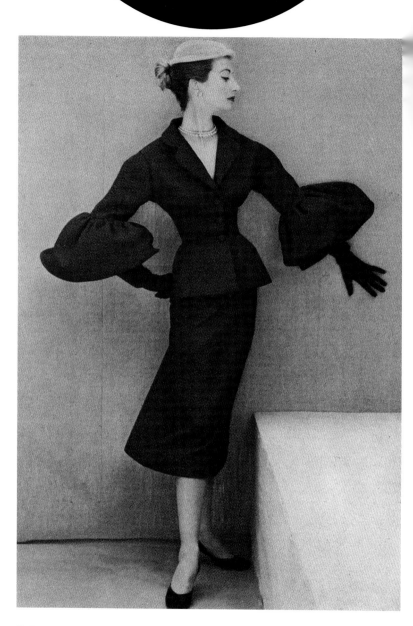

companies. This cocoon shape did not appear overnight but was instead a progression of a line Balenciaga had first proposed in 1942 when he designed a curve-shaped, three-quarter-length jacket that arched around the shoulders. This reworking and perfecting of cut and shape was a hallmark of Balenciaga's design methodology and his stylistic development and output.

The design also lays bare the other clear difference between the two post-war camps: the rapid change and heightened commercialism of Dior and his followers versus Balenciaga's preference for creating and introducing change and innovation at his own pace, showing that he was more concerned with creating classic styles than "Fashion" with a capital F. This approach meant his impact on the mainstream fashion world through replication by the ready-to-wear industry remained limited (with a few notable exceptions). Nevertheless Balenciaga quickly attracted a loyal and devoted set of customers and fans who appreciated his innovation and different method of working.

Very quickly Balenciaga's playing with space and volume developed into a bolder approach, and his dresses, suits and coats now started to take on increasingly large proportions through exaggerated draping and complex pattern cutting. The result was visually arresting and while very different from his contemporaries, it nevertheless had serious fashion gravitas, not least evidenced by the amount of coverage (and indeed covers) dedicated to his creations in upmarket magazines. In 1950, his mantle coat, an impressive yet wearable garment, presented a modern take on classic draping, while his now iconic bouffant, taffeta balloon dress which resembled two clouds was a striking play with volume. A year later the balloon motif was applied to the sleeves of an afternoon suit, again showing how Balenciaga took his time to explore and develop the full potential of shapes.

OPPOSITE Balenciaga tailored afternoon suit with balloon cuffs, *Vogue*, September 1951

Balenciaga's 1951 collection is considered by many a fashion historian to be the defining turning point in his aesthetic trajectory, as they argue that it presented models which would evolve and lead to future fashion revolutions. Most notable among these were his midi or Middy line – this would become "the tunic" – and his demi-fit which was the basis for his later sack dress. The "Middy", with its dropped waistline silhouette, was described by fashion editor Carmel Snow in *The Courier-Journal*, on 23 September 1951, as a line that "will bear watching". But it was near universally condemned by the mainstream press who (unjustly so) saw it as a return to the 1920s. Here are just two unfavourable comments from the press of the time, the first from *The New Yorker*, 22 September 1951, and the second from the *Indianapolis Times*, 15 October 1951:

> *"Balenciaga launched his long middy line with authority... We launch this objection with authority, too – we have behind us the authority of many millions of middle-aged, paunchy American males...It was one thing for us to cope with baggy, malformed women when Scott Fitzgerald was around to cheer us on...it's too much to ask us to accept girls whose pelvis appears to start just below the chin and look as though they had been hacked out of an old elm stump."*

> *"Mr. Balenciaga…is attempting to bring back the middy, the abominable style that made every woman look like a scarecrow in the Roaring Twenties…is preparing to get milady's hips slimmer, her derrière slimmer; well, just everything that has been built up over the years."*

While it was not a great success commercially, the importance of Balenciaga's 1951 collection lies, as noted above, in the fact

OPPOSITE Balenciaga Middy blouse top in tartan over a matching full-pleated skirt, *Vogue*, September 1951

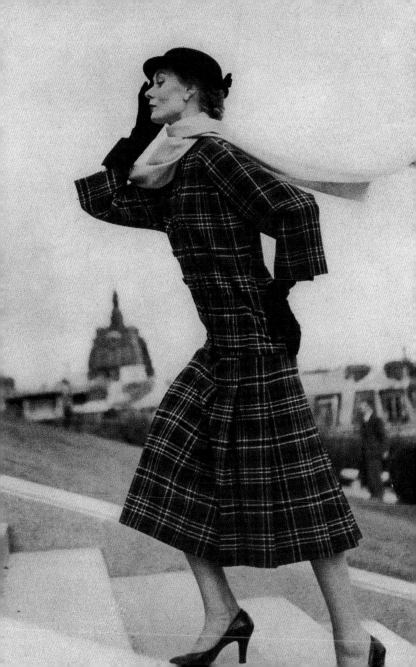

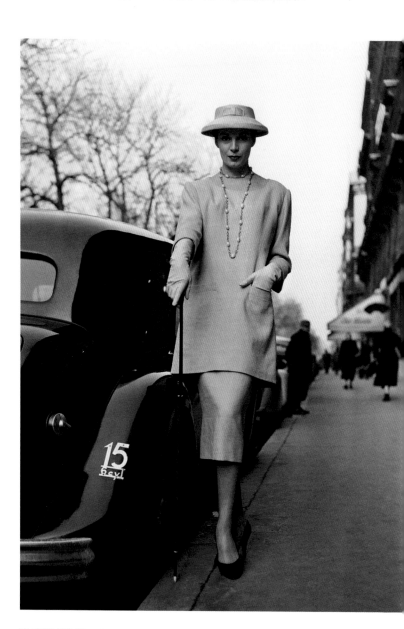

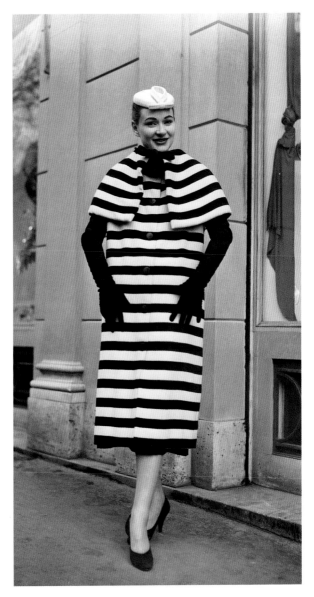

OPPOSITE Balenciaga
tunic silhouette, 1955

RIGHT Balenciaga
striped cape-coat,
1955

that it evolved into his tunic silhouette of 1955 and his sack/chemise dress of 1957.

Balenciaga's Tunic line, with its straight, slender cut that barely skimmed the body "represented a divorce between body and the dress" (*The Charlotte Observer*, 1 September 1955). It was initially met with mixed feelings: some journalists called the style a "shocker"(*The Philadelphia Inquirer*, 4 August 1955) and "deflated" (*The Morning Call*, 4 August 1955), but others praised its "wonderful newness" (*San Francisco Examiner*, 9 March 1955). On the one hand, the simplicity and linearity of the tunic dress drew emphasis away from the waist and, on the other, its skimming sheath nature proposed a different appreciation or celebration of femininity. More importantly, it set the tone for things to come, and was a clear precursor to the youth fashions of the 1960s.

However, it was Balenciaga's 1956–57 sack dress (also referred to as his chemise dress) – which had evolved out of his earlier barrel-, cocoon- and demi-fit lines – that took his level of abstraction to new heights and would consequently divide both the press and the public. Voluminous from the shoulders right to the tapered hem on the legs, the garment made no reference to the body within, which was completely de-emphasized. Its seemingly simple cut belied a technically complex structure. The waist, which had been such a focal point of Western fashion, was completely obliterated.

Traditionalists cried "infantalization" and deemed the sack dress a style only appropriate for children. These objections revealed more about prevailing ideas around femininity than they did about the sack, which, in fact, was the perfect symbiosis of dress and the female body and which had to be seen in motion to be fully appreciated.

A year later, Balenciaga's baby-doll dress, with its full, flaring trapezoidal design, once more played with volume and the

OPPOSITE Balenciaga black silk tunic with bow below the bosom, *Vogue*, October 1956

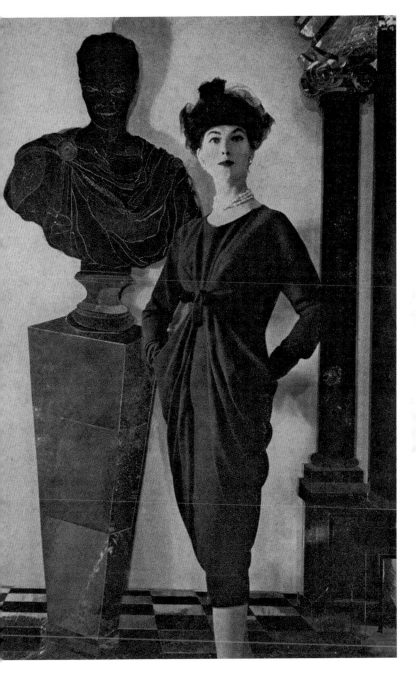

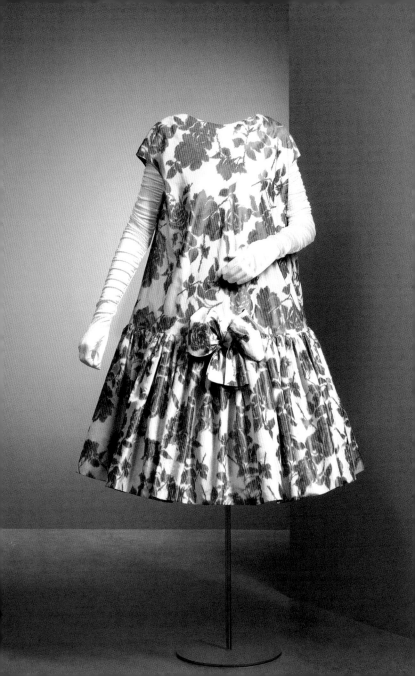

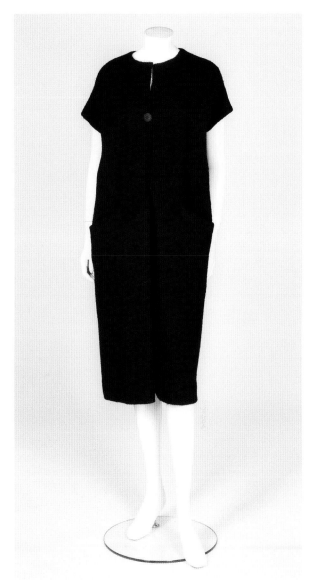

OPPOSITE Balenciaga
pink and white floral
baby-doll dress, 1958

RIGHT Balenciaga
black wool sack dress,
c.1962

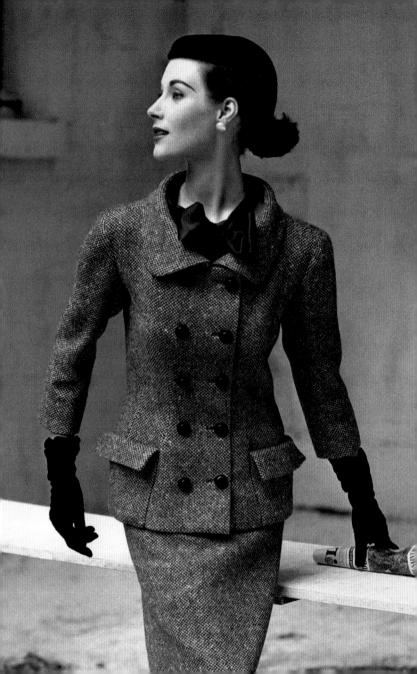

space between the garment and the body. The accusation of infantalization reared its head yet again, with some journalists describing the dresses – especially those executed in white and pastel-coloured cotton – as having "the look of a child's birthday party" (*The Philadelphia Enquirer*, 28 February 1958), while others compared them to a tea cosy (*The Salt Lake Tribune*, 29 August 1958). However, the aura of the baby-doll dress and its use depended on the fabric and colour in which it was executed. The transparent black lace versions, in particular, which were worn over a tight, black crêpe de Chine underdress, most certainly did not belong at a child's birthday party. Regardless of the more negative reactions, the trapezium-shaped baby-doll dress became a success and was quickly subsumed in other couturiers' collections.

It would be incorrect to think that these unfitted and increasingly experimental silhouettes meant Balenciaga completely renounced fitted clothing, as all his collections included tailored jackets and suits which were, in fact, his greatest successes from a commercial point of view. Indeed, many early businesswomen were great fans of his boxy jackets with slightly shorter sleeves that did not impede their hands in any way. A Balenciaga suit quickly became a symbol of success.

Aside from the baby-doll dress, the year 1958 also saw the introduction of the peacock-tail dress, which was based on the Spanish flamenco dress: short in the front and long in the back with a bunched, balloon skirt. An actual balloon-shaped dress from Balenciaga's Autumn/Winter presentation was arguably another step closer to abstraction and an almost outright denial of the body that it enveloped, but it still had an airy, almost weightless, appearance. This airiness would soon be replaced with a clean-cut rigidity, and his work with space would become less playful and more architectural – and come to define the final phase of his design career.

OPPOSITE Balenciaga double-breasted tweed suit, *Vogue*, September 1952

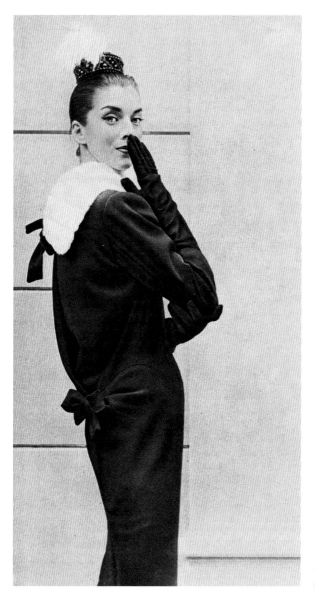

LEFT Balenciaga
black tunic gown
with back bow detail
and statement
hat, *Frankfurter
Illustrierte*,
September 1955

OPPOSITE Balenciaga
tiered balloon evening
gown, 1965

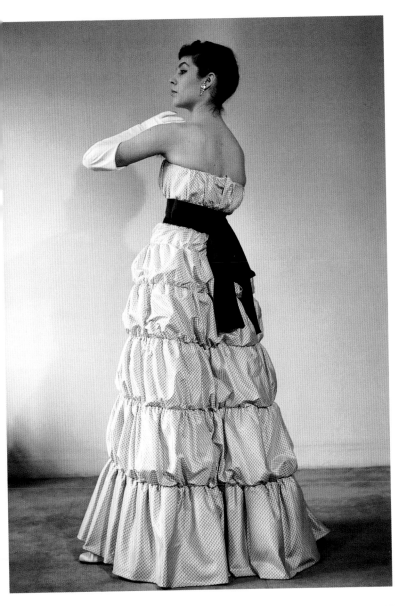

SPANISH
INFLUENCES

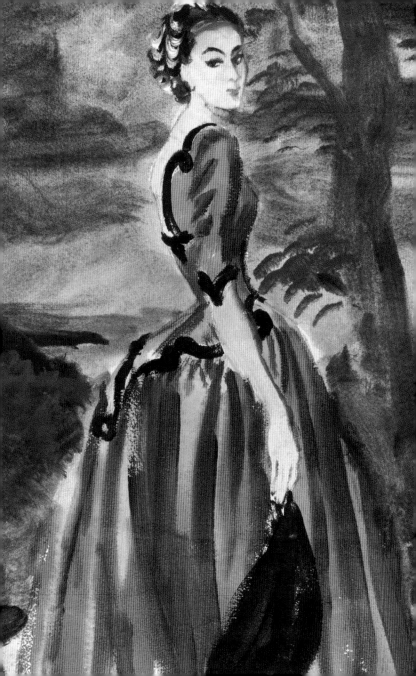

HOMELAND ECHOES

"[Balenciaga's] inspiration came from the bullrings, the flamenco dancers, the fishermen in their boots and loose blouses, the glories of the church and the cool of the cloisters and monasteries. He took their colour, their cuts then festooned them to his own taste." — Diana Vreeland, fashion editor

Fashion designers draw inspiration from different sources from one collection to the next, but many tend to have certain themes – leitmotifs, if you will – to which they return time and again, and Balenciaga was no exception. His overarching leitmotif is best described as Spanish-ness.

Even though Balenciaga moved to Paris in 1937 and worked out his career in this city, it needs to be remembered that he already had a near two-decade career under his belt in Spain. Indeed, his formative years and experiences were exclusively rooted in his native country. Even after settling in France and climbing to the top of the haute couture industry, Balenciaga always remained the "Spaniard in Paris" and maintained strong links with his homeland, his family and his Spanish businesses. He kept several flats and houses in Spain, where he would often travel for work and where he spent his holidays surrounded by family and a few chosen close friends.

OPPOSITE Balenciaga Velázquez or Infanta dress,
Vogue, September 1939

In Paris Balenciaga ran his couture house by bringing over the best staff from his Madrid and San Sebastián ateliers, and in turn he would send his most talented French staff to train at his Spanish enterprises. He never fully mastered French and it is no coincidence that many of the principal positions at his fashion house were occupied by Spanish speakers and that workroom conversations were mostly conducted in Spanish.

The press picked up on Balenciaga's close ties to his native country and many an article focused on the Spanish motifs and themes in his designs. In 1948, *Harper's Bazaar* asserted that "in his collection there is always an echo of his native land, an evocation of the Spain of brilliant colours, beads and paillettes, pompoms and the little matador jacket". While claiming that this was true of all his collections might be somewhat exaggerated, nevertheless many of these elements did indeed recur in his oeuvre. Even in his later, more austere and "clean" silhouettes the references to Spain were still there, albeit executed in a less explicit, more abstract and conceptual manner compared to the more literal translations in his earlier work.

Balenciaga's Spanish influences can roughly be divided into two categories (which we look at in this chapter and the next): traditional, historic and folk dress, and religious dress, although in reality the division is less clear-cut since religion had permeated all aspects of Spanish life over the centuries and inevitably filtered through into folk costume. While it is impossible to explore all the elements and details in Balenciaga's work in this volume, the major themes and references that led to important innovations will be addressed, so as to identify not only where his ideas came from but also how they were used.

The matador jacket, or *traje de luces*, was a favourite source of inspiration, and lavishly embellished and beaded bolero jackets were found in several of his pre-1950s collections. As noted by

OPPOSITE Balenciaga "Infanta" dress, 1939

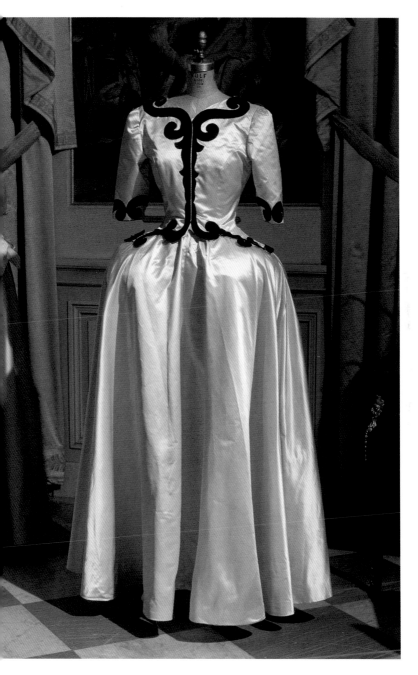

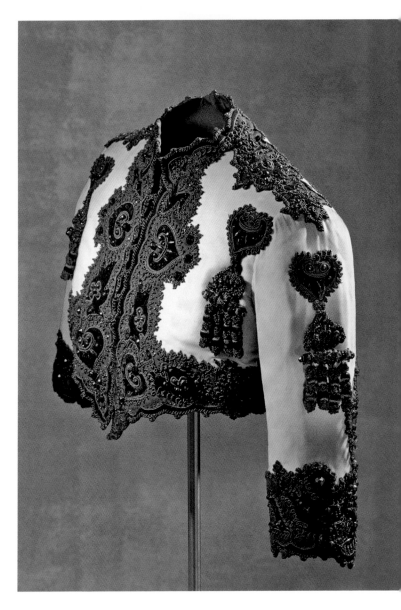

Miren Allurez – whose research features in Hamish Bowles's 2011 book *Balenciaga and Spain* – San Sebastián was the first Spanish city to advertise bullfights, with posters often featuring renditions of the glamorous matadors, so it is very likely Balenciaga grew up surrounded by this imagery. He is said to have hated real bullfights, but since the late nineteenth century the imagery of the bullfighter had been closely associated with Spanish national identity and public imagination – so Balenciaga's use of this as a reference is neither contradictory nor surprising.

One of the first mentions by the international press of a matador reference appeared in 1939 when *Harper's Bazaar* featured Balenciaga's "bullfighter snoods" (1 September 1939), but the first actual bullfighter-inspired jacket did not appear until 1943 and was illustrated for the French fashion press by Raymond Brenot. A year later, in his first post-Liberation collection, which was described as including "all Spanish ideas" (*The Province*, 9 December 1944), Balenciaga presented afternoon dresses worn with sequinned, crocheted, knitted and embroidered boleros, but his most spectacular versions, those most closely modelled on the matador jacket, were executed between 1946 and 1949. Aside from the matador jacket, and specifically its traditionally rich embellishments, the colour palette of the bullfighter costume can also be discerned in several of his creations, specifically his use of brilliant yellow and bright pink, which were two colours traditionally used for the matador cape. The matador hat – the *montera* – also appeared in various incarnations; these often tended to be paired with almost austere silhouettes as if to add an element of playfulness, but also to avoid a result that too closely resembled costume or looked old-fashioned – Balenciaga may have referenced tradition and the past, but the outcome was always resolutely fashion that presented new ways of using these ideas.

OPPOSITE EISA blue
matador bolero, 1947

Spanish dance dresses, and the flamenco dress in particular, were another source of inspiration to which Balenciaga returned on several occasions. Flamenco dancers had captured the imagination and attention of artists since the nineteenth century, when *café cantantas* (cabarets) had started introducing flamenco to popular culture – artists such as Gustave Doré and John Singer Sergeant, and others, were all captivated by this fierce gypsy dance. The 1920s saw a revival of flamenco and, indeed, gitano (gypsy) culture in an effort to preserve their traditions, and this was therefore another aspect of Spanish-ness that was part of Balenciaga's formative years. Flamenco dancers such as Carmen Amaya and La Argentina, and later Lola Flores, became international sensations and introduced new audiences to the dance and its costume: the *bata de cola*.

The *bata de cola* dress was designed so as to extend the line of the flamenco dancer and exaggerate and dramatize the rapid flips of the flounced train. Balenciaga repeatedly used the *bata de cola* in his creations, both literally and in more abstract evocations. Sometimes the inspiration was found in the shape, sometimes in the fabric choice, at times in both. From the black velvet evening gowns with pink silk taffeta or white tulle ruffles from 1951 which closely mimicked the lines and effect of the flamenco dress, via his 1960s black-and-white, polka-dot creations, to his more abstract peacock dresses with ruffled hems of the late 1950s, or their pared-down successors from the 1960s, the austere, silk gazar versions… all found their origin in the flamenco dress.

Aside from these two iconic costumes that were so aligned with Spanish national identity, Balenciaga also explored Spanish regional costumes that were less familiar (particularly to non-natives) but which also regularly found their way into his aesthetic language. Prior to his move to Paris, he had travelled extensively in Spain, which at the time was going through a renaissance of

OPPOSITE Balenciaga flamenco-style evening gown with shocking pink taffeta on the graduated skirt, c.1958

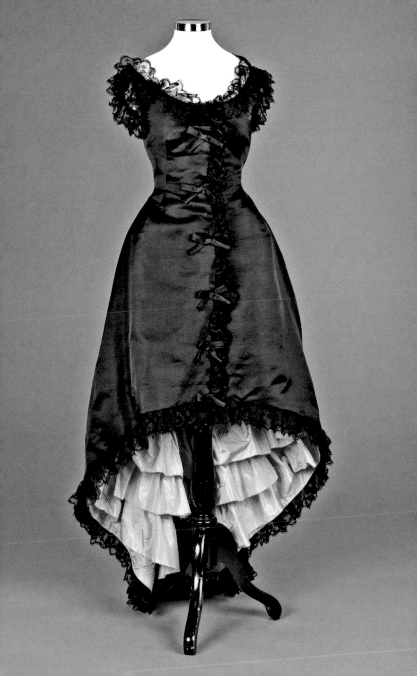

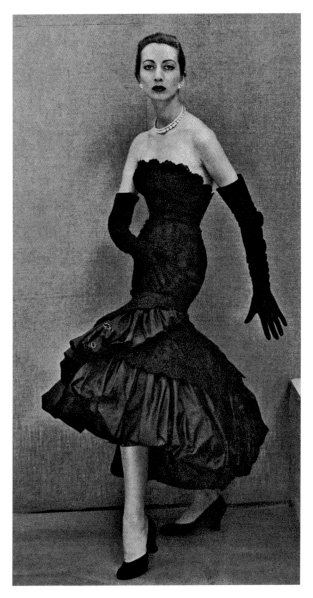

OPPOSITE Balenciaga polka dot evening dress, 1959

LEFT Balenciaga black lace-over-taffeta sheath with a double frill fan skirt, *Vogue*, September 1951

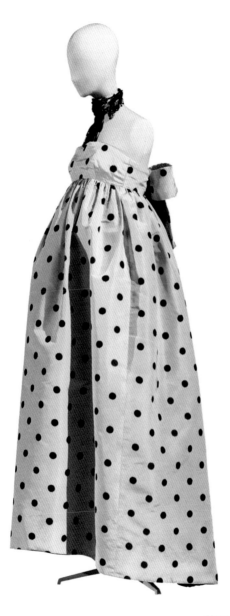

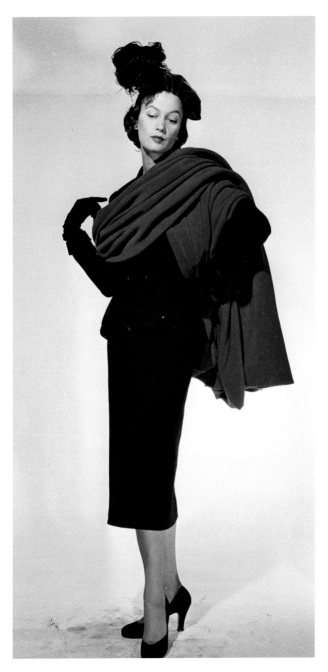

LEFT Balenciaga wool suit with large draped scarf, 1950

ocal and folk culture, so his exposure to this heritage was natural and inevitable. He is said to have collected folk and regional costume, and printed sources on Spanish dress history, and taken all together this goes a long way to explain the references that would crop up throughout his career: the pleated skirts of Cáceres, the rich appliqué work of Salamanca and the headdresses of Navarre…these were all reflected later in his creations.

One item of dress that needs specific mention is the cloak or cape. These were found in many regional dress styles across Spain, and it is no surprise that they were also a near constant in Balenciaga's work. Throughout his career he showed, as Hamish Bowles observes, "capes and cloaks in the manner they were worn in Spain" – that is, often voluminous and/or expertly pleated. His cape from 1956, which could also be worn as an overskirt or apron, finds close parallels in the folk dress of several regions – although Ruth Anderson notes in her book *Spanish Costume: Extremadura* that "the habit of using the upper skirt as a cloak is common". His 1950 pleated and draped cape coats also owed a clear debt to the cloaks of Northern Spain.

Balenciaga did not limit his referencing to traditional costume (which was often used for special occasions such as weddings or religious festivals); he also looked towards Basque everyday workwear. The beret, worn by Basque shepherds, can be repeatedly found in his 1960s' output, but it was the traditional shepherd's loose-fitting shirt jacket that would have the most profound fashion impact through its translation into his post-war suits and revolutionary blouses and tunics.

Through his creative reworking of the traditional and folk elements of Spanish costume in his couture creations, Balenciaga not only introduced his country's sartorial heritage to a global audience, but more importantly his conceptual play within workwear revolutionized the post-war female wardrobe.

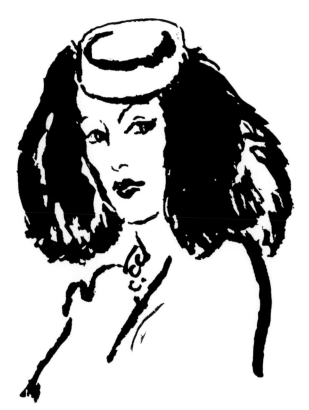

OPPOSITE Two
Balenciaga Goya-
inspired pannier
dresses, *Vogue*,
July 1939

RIGHT Balenciaga
"Velázquez" hat made
of violet felt flanked
with fox tails, *Vogue*,
September 1939

RELIGION

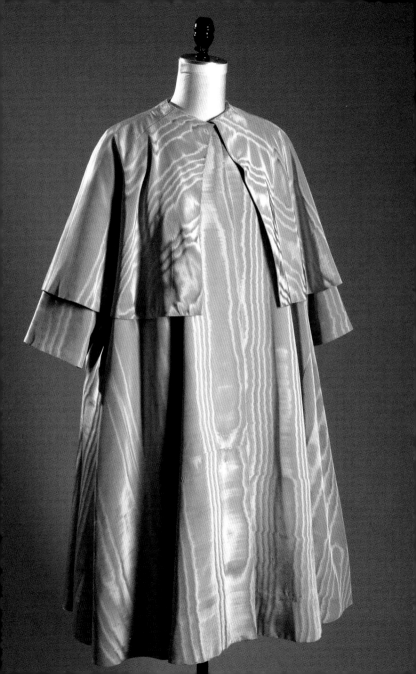

TAKING THE CLOTH

"The simple and minimalist lines of religious habits and the
architectural volume of the fabrics were a constant in his pieces."
— Eloy Martínez de la Pera Celada, curator

As we saw in earlier chapters, both Spain and Spanish-
ness shaped and became a strong thread throughout
Balenciaga's career. The previous chapter identified some
of the major themes that linked his designs aesthetically to his
home nation but one specific subset, as it were, of the Spanish
influences that shaped his work, and indeed his life, more
profoundly than any other, was religion. As Hamish Bowles,
writer and curator, explains: the "profound and pervasive
influence of the Catholic church on the Spanish psyche and
on its culture and its art was abundantly manifest in
Balenciaga's work".

Balenciaga was a devout Catholic his entire life. A
committed altar boy from an early age, he toyed with the
idea of following his uncle into the priesthood, but even
though he changed course to embark on a career in fashion,
his commitment to the Church remained strong. Indeed,
on several occasions he applied his expertise to executing
religious vestments – most notably the cassock worn by the
priest who gave Christian Dior's eulogy at his funeral in 1957
– and choral gowns. The couturier André Courrèges, who

OPPOSITE Balenciaga silk moire evening coat inspired
by a cassock and cape, 1950

trained under him, remembered the opening and closing of his mentor's office door at least once a day as he went off to pray in a nearby church.

Balenciaga's commitment to Catholicism can be discerned in creations throughout his career, but his later designs in particular owed much to the austere yet imposing nature of religious dress. His designs reinterpreted elements from nuns' habits, priests' chasubles and cassocks, monks' hooded robes, religious head coverings and even the embellished robes that clad the statues of the Madonna carried through the streets during Holy Week.

The inspiration he drew from religion can be roughly attributed to two sources: he was inspired both by its practice and role in Spanish life and by its historic representation in Spanish art history. Once again it would be impossible to address every single instance of inspiration or reference in this book, but by examining a few choice examples it will become clear just how Balenciaga incorporated religious tradition and art into his designs.

The relationship between fashion and religion might appear to be one of opposites, but Catholicism in fact has a close and longstanding relationship to cloth and material: not merely through the religious vestments worn by men of the cloth, but also through its historic modesty diktats and sumptuary laws, its ceremonial use of fabrics and garments and the importance of materials in transubstantiation and relics. The shift in focus of the young Balenciaga from a life dedicated to the Church to one dedicated to fashion is therefore not as dramatic as it may at first appear. Neither was his continued use of religion in his oeuvre, especially as he always aimed to respectfully translate tradition into something original and modern – while the references were there, they were never easy, literal or derivative.

As with all his techniques and influences, once Balenciaga had settled on "something", he took his time to explore, test and

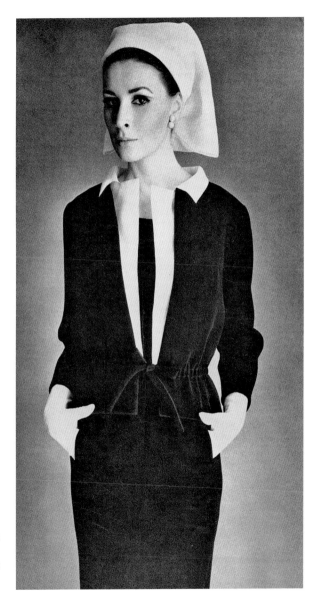

RIGHT Balenciaga
sleeveless black
alpaca dress and
short, tie-waisted
jacket with white
organdie, styled with
a hat resembling
a nun's wimple to
highlight Balenciaga's
use of religious
influences, *The Tatler*,
24 March 1965

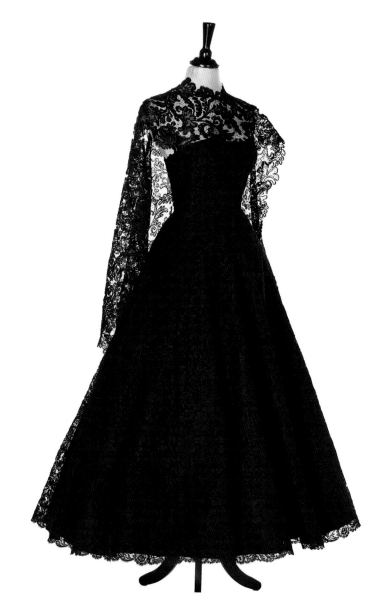

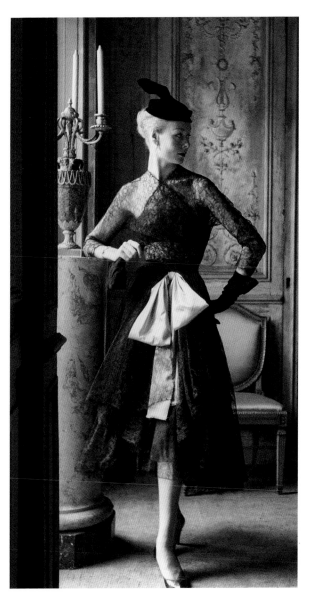

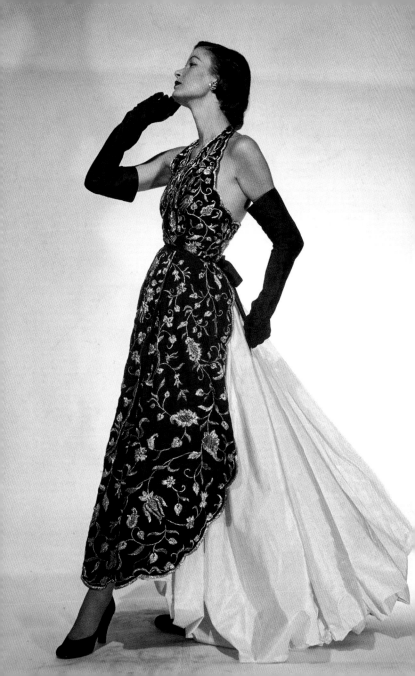

develop it to its limits. His religious influences were no different. Owing to this approach, the mantilla, a delicate Spanish lace scarf worn over the head and shoulders, was reinterpreted as fashion on numerous occasions. White mantillas often accompanied Balenciaga's wedding dresses and his 1950 collection featured a black mantilla embroidered with gold thread paired with a flamenco-inspired, tiered, tulle dress. On other occasions, he bunched the mantilla into bodices, capelets or puff sleeves, or layered the delicate black lace over brightly coloured silks; his most famous use of black lace was in his iconic 1958 baby-doll dress.

Another potent source of inspiration were the lavish embroideries on chasubles and those on the brilliantly coloured robes created for Madonna figures. Writer, biographer and journalist Judith Thurman observes that Balenciaga "adapted the vestments of his parish church…for the wardrobe of the worldly woman" and, indeed, the influence of the embellishments of these robes can be clearly discerned in some of his most spectacular evening gowns. Not only did he interpret the traditional metallic gold and silver designs, but their placement on his creations – with the focus on the bodice and hem or all-over scattered motifs – also referenced their originals. Further examples include an exquisite purple, silk velvet coat from 1951, evoking the robes of popes and cardinals through both its cut and colour, and the billowing drapery of much of his early 1950s work that bears a striking resemblance to Spanish religious art from the seventeenth and eighteenth centuries – which, incidentally, he collected.

A black evening cape and gown from 1967 resemble both a friar's habit and a cardinal's mozzetta and the austerity of the cut, set off by the luxurious fabric, embodies the "excessive restraint" that is central to Catholic art. Balenciaga's iconic one-seam wedding dress from the same year has a stiff, structured veil modelled on a nun's wimple and is a triumph of construction,

OPPOSITE Balenciaga embroidered organza apron dress with taffeta train, 1950

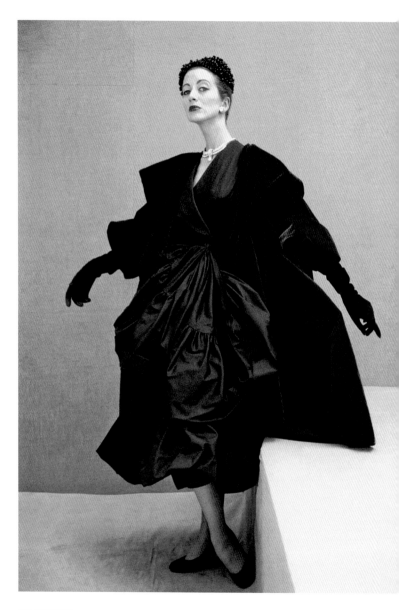

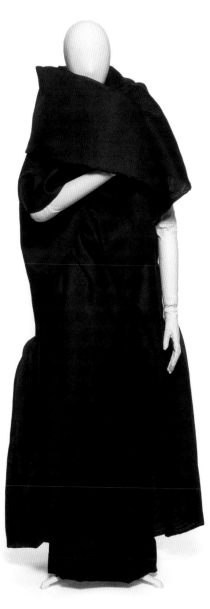

OPPOSITE Balenciaga black taffeta wrap dress with a balloon-frill hemline under a wide-sleeved cape-collared purple silk velvet coat, 1951

RIGHT Balenciaga evening wrap coat, 1962

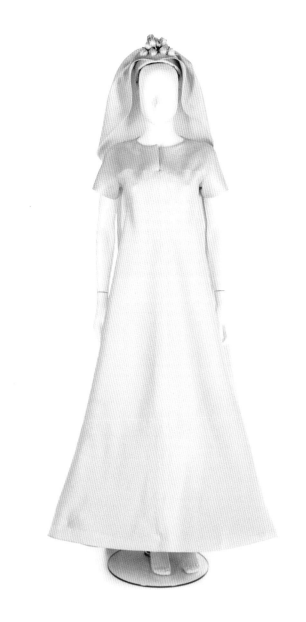

LEFT AND OPPOSITE
Balenciaga ivory
slubbed silk gazar
bridal gown and
matching EISA veil,
1968

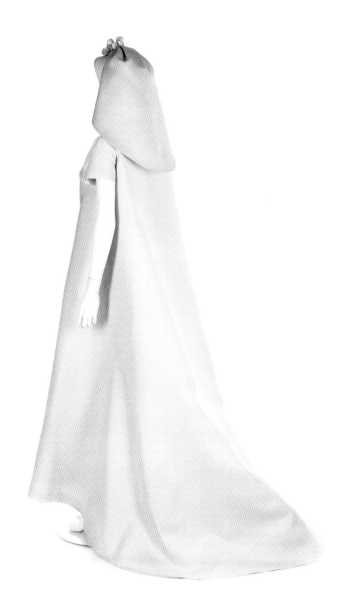

restraint and modesty. Even his love for and prolific use of deep black can be understood in the context of Catholic asceticism.

Balenciaga's engagement with Catholicism extended beyond the lived culture he had known since he was a young boy and encompassed its representation in Spanish art – references to Spanish art, and specifically religious art, were always highly present in his work. The direct relationship between his work and painting first became explicit in 1939 through his Infanta dress, but it's his post-war garments that were more conceptually related to religious art. Many of Balenciaga's wedding dresses resembled the cut and draping of the garments worn in Francisco de Zurbarán's seventeenth-century paintings of monks and saints; his early 1960s evening dress and jacket combinations bore more than a striking resemblance to Goya's painting of Cardinal Luis María de Borbón y Vallabriga; his choice of deep blues, crimson reds and mustard golds…all are straight out of El Greco's colour palette for his religious paintings.

It's worth noting that the influence of religion was seen not just in his creations but also in their making, his Parisian workrooms and salon being described by various parties as monastic. There was near total silence – any minimal conversation was conducted in hushed tones. The atmosphere was not unlike that of a church, and its seriousness and severity were felt by all visitors. Balenciaga's all-consuming focus and concentration during the making process could be described as akin to praying, and some of his closest co-workers testified that when he was trying to perfect the cut of a dress or figure out a pattern, he would pass a small piece of fabric between his fingers just as one would a rosary. Catholicism was a constant in Balenciaga's life, proving an enduring source of inspiration and reference, and indeed he worked at his craft with a near-religious devotion throughout his career to reimagine historic, religious costume in a modern and relevant way.

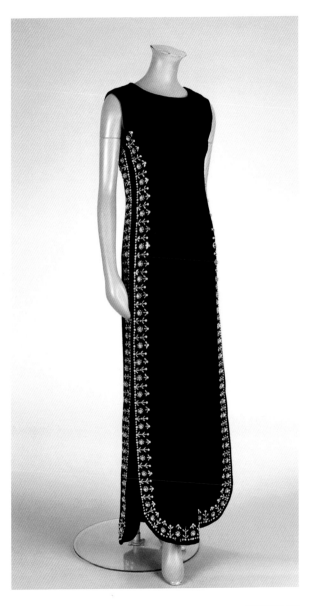

RIGHT
EISA black velvet
evening gown bearing
black EISA label,
curved front and
back panels edged in
dramatic gold beads,
silver leaf-shaped
sequins, pearls and
rhinestones, 1967

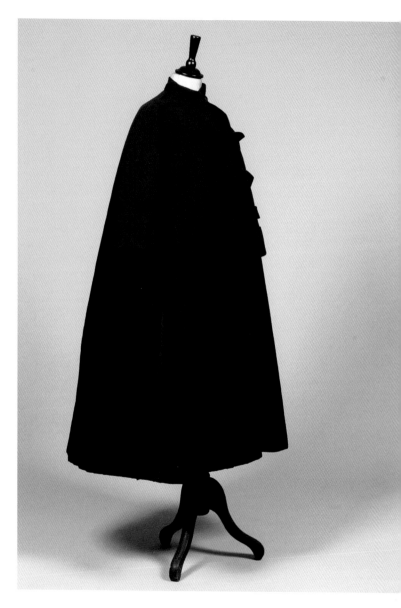

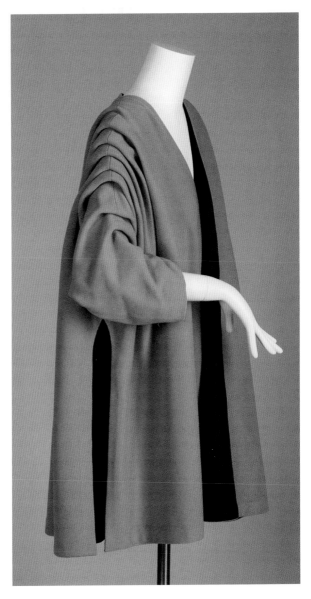

OPPOSITE Balenciaga
black silk faille coat
with short stand
collar in the style of a
cassock, c.1957

RIGHT Balenciaga
wool gabardine and
silk taffeta pleated
and draped coat, 1950

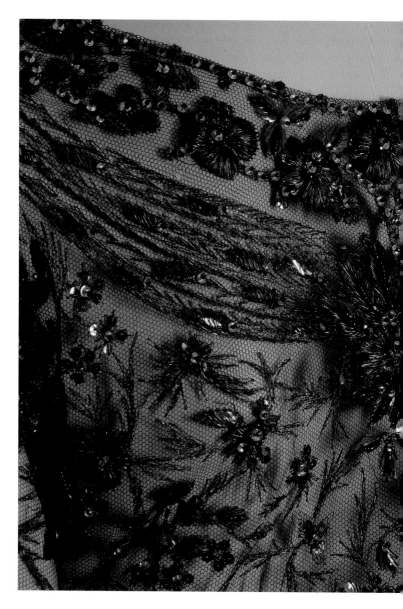

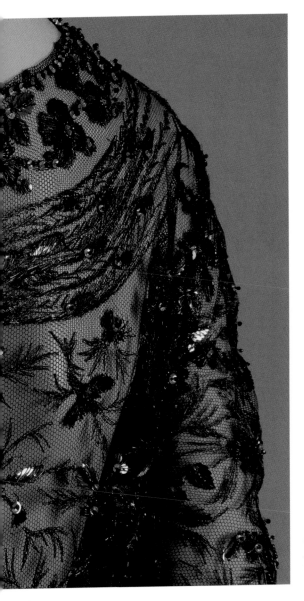

LEFT Back detailing on
a Balenciaga evening
jacket made up of silk
faille, net, glass beads
and sequins, 1955

THE MASTER
OF MODERNITY

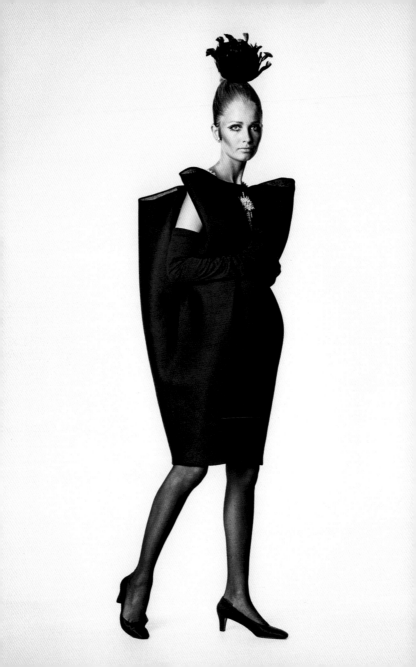

THE ARCHITECT OF HAUTE COUTURE

"Austerity and sobriety, balance and proportion, coherence and perfection, innovation and timelessness."
— Eloy Martínez de la Pera (art and fashion curator)

In many ways, Balenciaga's creations of the 1960s are best understood as a refinement of the designs, techniques and shapes he pioneered in the 1950s, highlighting his modus operandi: working and reworking ideas over time to test their limits and perfect them. Many of the silhouettes produced by Balenciaga in his final years as haute couturier are those for which is best remembered and the ones that were instrumental in earning him the accolade given by Hubert de Givenchy – he was the "architect of haute couture".

While Balenciaga's experiments with volume, which characterized his oeuvre during the 1950s, retained a sense of airiness, his 1960s work took on a more austere character. He presented more rigid architectural and moulded shapes which were achieved through a combination of new materials and mathematically refined patterns. The geometric shapes favoured by Balenciaga were constructed from cylindrical and spherical patterns and the joining of half circles. Yet while the finished product, devoid of all surface decoration so as not to distract

OPPOSITE Balenciaga "Envelope" dress, *Vogue*, September 1967

from the pure line of the silhouette, might appear minimal or straightforward, it was anything but. In fact, the perfect balance of his creations barely do justice to the complexity of their inner workings – each aspect, every detail, every cut and stitch was carefully planned out, worked and reworked to realize the master's vision.

Balenciaga's work from this period is often referred to as minimalist, positioning it alongside art and architecture, to which it has indeed been compared ever since. It has been suggested that his increasingly abstract experiments with form were paralleled by an increasing engagement with the world of contemporary art through his friendships with art collectors, and that the work of artist Joan Miró was particularly influential.

Although this is one way of framing the creations that defined the final phase of Balenciaga's career, it is perhaps more useful to think of these designs as the culmination of his ideas and craftsmanship. Indeed, the former "explanation" would imply a departure from his earlier influences and design themes, while thinking of them as the designs of a "young man with all the knowledge" (as described by Pauline de Rothschild, a socialite and Balenciaga customer) not only acknowledges that his design inspirations in the 1960s were a continuation of those that went before, but also highlights the garments' innovative and visionary qualities and honours the highly developed pattern-making and sewing skills that went into making them. They were the work of someone with a young eye and spirit as well as the skills and experience of a seasoned master. As historian Eloy Martínez de la Pera puts it: "his constant search for perfection translates to the rigorous, almost obsessive process of creation that seeks the most special aspects of the fabrics, cut and body and in which finishes, and sometimes inappreciable details, are essential for devising the perfect attire for imperfect bodies, making them beautiful."

OPPOSITE Balenciaga dark blue silk dress and cape, early 1960s

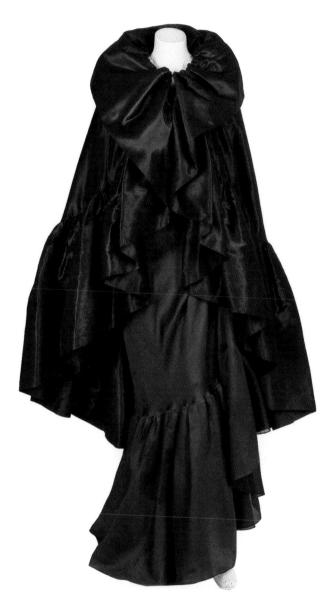

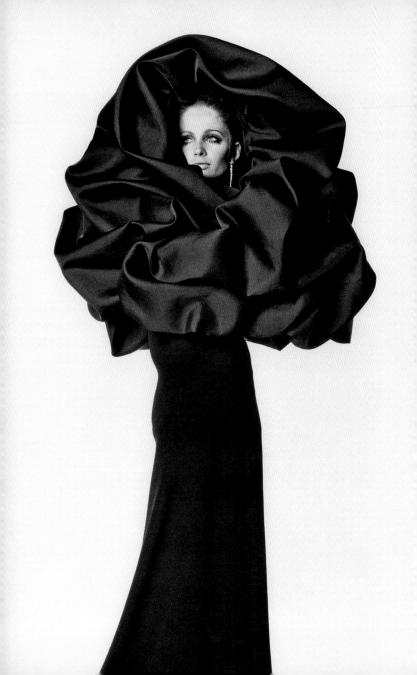

As we have seen, his tailoring work took on stylistically architectural tendencies, in both his arresting evening and occasion wear and his daywear suits. Balenciaga's dresses and coats at times moved closer to sculpture than clothing and yet remained – with a few exceptions – comfortable to wear. In this period, he returned to his earlier explorations of the garment as a capsule, involving the creation of sculptural space between the body and the clothing, an idea rooted in traditional Japanese pattern-cutting. From 1962 in particular, this translated as a move into increasingly abstract shapes that go beyond the body and resulted in truly novel, yet refined and timeless, silhouettes that enveloped the body but did not constrain it. Nor were the garments or silhouettes constrained by the body.

It should be emphasized that these creative leaps were both driven and underpinned by Balenciaga's deep knowledge of fabric and his use of materials. For his coveted tailored daywear suits he favoured mohair and wool mixes and substitutes (whose creation he was often closely involved with), while for his sculpted evening and formal wear he worked in silk faille and, more importantly, gazar, a fabric that he commissioned in 1958. Gazar was developed by the Swiss textile firm Abraham and was thicker and more pliable than other silks on the market due to its high-twist, double silk thread, which also gave the material a crisp, smooth texture. The fabric was perfect for both Balenciaga's love of highly ornate embroidery work (which decreased but far from disappeared in his custom-made work of the 1960s) and his need for a material that was capable of supporting his new architectural shapes. Gazar allowed Balenciaga to create volume through its inherent qualities rather than having to rely on supporting under-structures. His 1967 envelope dress and his chou wrap from the same year perfectly illustrate the structural possibilities of gazar, the dress being aptly described by curator and historian Alexandra

OPPOSITE Balenciaga chou wrap of crumpled black gazar that wraps around the head like a huge rose, *Vogue*, September 1967

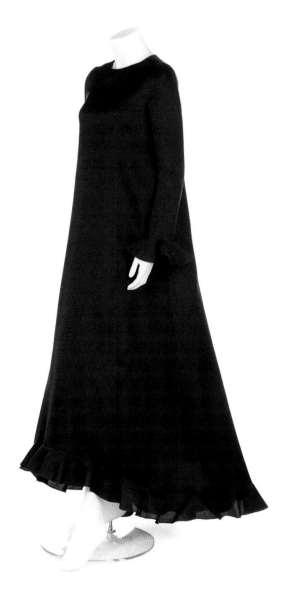

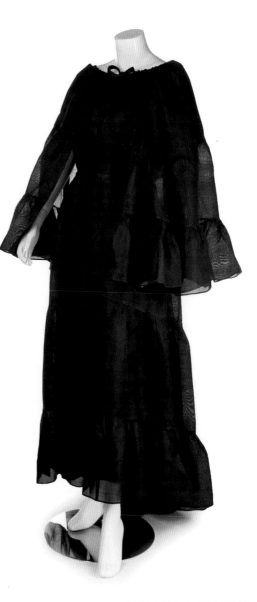

OPPOSITE Balenciaga
black gazar evening
gown with flounces
to cuffs and trained
hem, 1967

RIGHT Balenciaga
black couture gazar
evening gown and
cape, 1962

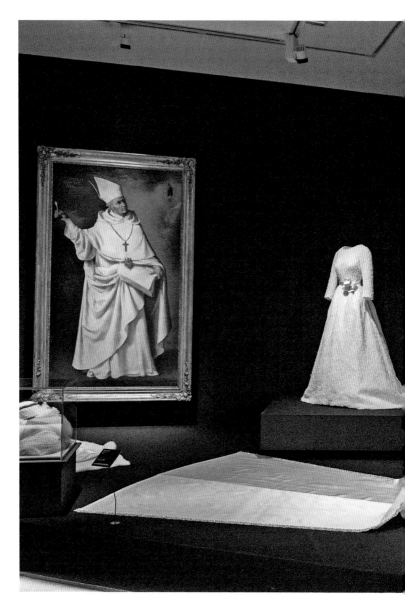

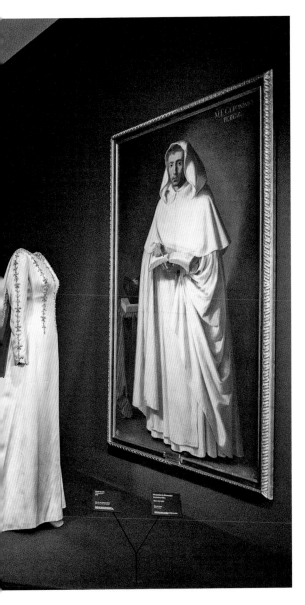

LEFT Cristóbal Balenciaga's final creation: María del Carmen Martinez-Bordiú's wedding dress, 1972

Palmer as a "study in cloth; a science experiment in gravity and structure".

Although a continued use of the descriptive labels "architectural" and "modern" for Balenciaga's creations during this time are aesthetically correct, they also obscure his design references. As noted earlier, they suggest a rupture with his design past when, in fact, there is a clear continuation of inspiration and references in his work throughout his career right up until his final collection. Arguably, Balenciaga's work in the 1960s is his most modern-looking, especially to contemporary eyes, but it should be stressed that he also continually returned to historic painting and costume as sources of inspiration. He presented his own conceptual and modern interpretations of the voluminously draped costumes portrayed in seventeenth-century Spanish painting, and many of his creations owed a clear debt to historic liturgical vestments in their austere simplicity and silhouette – for example, a dress and ruffle-shoulder cape from 1965 in deep blue gazar evokes El Greco's late-sixteenth-century painting "The Virgin Mary" and Bartolomé Esteban Murillo's seventeenth-century painting of the Virgin Mary, "The Immaculate Conception of El Escorial". Moreover, Balenciaga's wedding dresses recall the robes of friars, as depicted by artist Francisco de Zurbarán; a 1960 red satin ensemble is indebted to artist Francisco Goya's painting of Cardinal Luis Maria de Borbón y Vallabriga; his 1967 black gazar evening gown and cape resembled a monk's habit; and his single-seam wedding dress of the same year featured a headdress that bore a close resemblance to a nun's veil. However, while his references may have been rooted in history, their translation into fashion was never outdated.

It has been argued that Balenciaga did not understand the social upheavals which had started changing the fashion landscape by the late 1950s and would come to dominate the 1960s. In

terms of the fashion business, haute couture was fast falling out of favour, with the young increasingly turning their backs on Parisian exclusivity in preference for an expanding ready-to-wear market. This may well be true, but it would be wrong to extend that to Balenciaga's creative output or to think that, design-wise, he was outdated, old-fashioned or irrelevant. In fact, Balenciaga, more than many of his haute couture contemporaries, continued to experiment with new shapes, fabrics and techniques, and the results were truly innovative right until he closed his fashion house in 1968. His penultimate collection featured short suits, one- and no-seam dresses, and extraordinary trapezoidal evening dresses.

Balenciaga's position as an innovator in an outdated system is best illustrated by his 1968 work for Air France. He was asked to redesign the flight attendant uniform, a prestigious commission that evidenced his position as one of the fashion greats and a name known the world over. He created stylish summer and winter uniforms that looked as if they could have come straight out of his haute couture collections. There is no doubt they were elegant and expertly cut. However, this was 1968 and soon a wave of protests, strikes and political and social revolution would sweep across Paris and the rest of the world. Elitist elegance was no longer the order of the day and was now associated with the outdated world that the young were trying to discard. Staff and press alike condemned his creations as irrelevant and not fit for purpose. Fashion designer Ted Lapidus lamented Air France's choice and stated that Balenciaga's creations were "ravishing for getting out of a Rolls Royce or attending a soirée, but not for walking down the aisle of a Boeing". A harsh verdict that perhaps says more about the zeitgeist in which the uniforms were launched than the designs themselves, but nevertheless a low and undeserving note on which to end such an illustrious and important career.

RIGHT AND OPPOSITE Air France flight attendants wearing the company's new uniform created by Balenciaga, December 1968

Seeing clearly what was on the horizon and sensing there was no room for haute couture in the modern world, while also suffering from ill health, Balenciaga retired and closed his salon in May 1968, days after violence erupted on the streets of Paris. He came out of retirement briefly in 1972 to create the wedding dress for General Franco's granddaughter María del Carmen Martinez-Bordiú y Franco. The dress was made in Madrid under his strict, hands-on supervision. Two weeks later, Balenciaga passed away at the age of 77.

Women's Wear Daily titled their story on his passing simply as "The King is Dead". He was laid to rest in the cemetery of his beloved native Getaria.

A LABEL
REBORN

BALENCIAGA AFTER BALENCIAGA

When Balenciaga closed his salon in May 1968, regrettably his staff had to find out through the press. This was not because he had failed to inform his workers but because the termination letters that he sent them did not arrive for weeks and weeks due to the strikes that were crippling France at the time. Both the press and his devoted customers were full of praise for his achievements and lamented his retirement; it is said that socialite and long-time Balenciaga customer Mona von Bismarck took to her bedroom for three days to mourn.

Unlike today, designers who had founded their business in the early decades of the twentieth century did not expect their houses to survive them, and, indeed, many famous names disappeared completely post-closure. While couture production ceased when Balenciaga closed his atelier doors, his perfumes continued to be retailed after the closure and the house name remained in the ownership of his heirs until 1978, when they sold it to the German pharmaceutical company Hoechst AG.

Seven years later, Balenciaga was sold again, this time becoming part of the Jacques Bogart perfume group. It was

OPPOSITE Balenciaga bell-shaped dress, ready-to-wear, Spring 2008

during their ownership that serious efforts were made to re-establish the name as synonymous with high-end tailoring combined with classic elegance, by the appointment of Michel Goma as head designer. Goma had trained at couture houses such as Patou and Jeanne LaFaurie in the 1950s and '60s and was known for the immaculate cut of his designs. But Balenciaga the brand would not be associated with haute couture again until 2021 as its fashion revival had meant a shift to high-class, ready-to-wear clothes. In a way, this helped the brand make the transition and compromise required in the modern fashion landscape which had been refused by the master himself.

Goma deliberately mined the brand's archive for inspiration and reworked the originals into elegant modern classics for professional women, so following in its founder's footsteps. He became known for silhouettes that were well-sculpted, simple and minimalist, yet elegant and refined.

In an effort to raise the brand's profile the Bogart group closely controlled which retail outlets were allowed to stock Balenciaga. The strategy paid off and by the early 1990s the brand had a loyal fanbase once again.

In 1992 Goma was replaced by Josephus Melchior Thimister, who had trained at Lagerfeld and Patou. Like Goma, he consciously chose to reference the original Balenciaga oeuvre and specifically the semi-tailored look. Thimister quickly became known for his exquisite cutting skills and minimalist style – just like his predecessor, he favoured references from Balenciaga's later years. He contributed further to the elevation of the brand's profile, and when he left in 1997 to start his own label Balenciaga was again a relevant brand worn by celebrities and high-profile women around the world.

Thimister's successor, Nicholas Ghesquière, had joined the brand two years earlier to work on its Asian licences. Like Goma

ABOVE LEFT
Balenciaga dress with
matching cape, ready-
to-wear, Fall/Winter
1989–1990

ABOVE RIGHT
Balenciaga hooded
dress, ready-to-
wear, Fall/Winter
1996–1997

and Thimister, he had earned his couture stripes – in his case, at Jean Paul Gaultier. In 1997, aged 25, he was promoted to head the house and his highly lucrative collections saw Balenciaga not only becoming a household name but also a favourite among the young and fashionable. This was in part down to his canny strategy for selling accessories. Ghesquière realized that aside from perfumes a brand's bread-and-butter business came from the sale of accessories and, specifically, the growing popularity of It bags. In 2000, he introduced the First bag, which was followed by the City bag not long after. Both were huge commercial successes, not least because they were seen on the arms of a host of celebrities, including Nicole Richie, the Olson twins, Sarah Jessica Parker and Sienna Miller. All these celebrities had serious fashion clout. As darlings of the paparazzi, they were featured daily carrying their bags while going about

their business, fast making Balenciaga bags the most desirable accessories around and vastly improving the brand's finances.

Ghesquière never personally knew Balenciaga nor was he around during the master's heyday, having been born only a year before his death, but he familiarized himself with his oeuvre and often paid homage to it in his designs. While these design nods were possibly not as explicit as his predecessor's ability to make history relevant to contemporary audiences through his own personal vision and interest in new materials, they nevertheless drew a clear link between the two.

In 2001, the brand became part of Gucci, which itself became part of the Kering Group in 2004. In the same year, Ghesquière launched the Edition collection of "original designs reworked and reissued to suit the mood of fashion".

In 2012, Ghesquière moved to Louis Vuitton and was replaced by Alexander Wang, who was the first creative director at Balenciaga to come from a ready-to-wear background instead of a couture one. His three-year stint saw the brand cementing its move into designer branded goods, with a proliferation of high-profit items such as T-shirts and trainers making up a significant part of the brand's offerings.

Although to many the choice of Wang – who brought a decidedly street- and youth-wear aesthetic and experience with him – seemed weird and mismatched with the Balenciaga heritage, he nevertheless managed to create interesting and commercially viable collections which featured historic references that were updated with a sporty American twist. Kering's aim in hiring Wang was to "imbue a sense of modernity and youthful energy to the house", and while original brand devotees may have objected, there is no doubt he managed to achieve exactly that: he significantly widened the Balenciaga customer base and made the brand relevant to a young new audience.

OPPOSITE Balenciaga evening dress, ready-to-wear, Fall/Winter 1997–1998

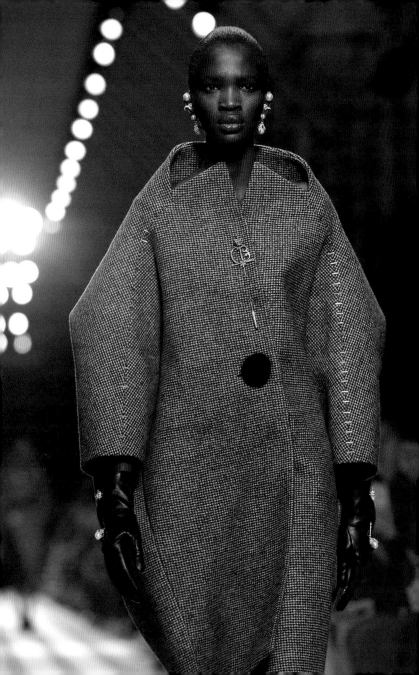

OPPOSITE Balenciaga rounded tweed coat with stand-up collar, ready-to-wear, Fall/Winter 2015–2016

ABOVE LEFT Balenciaga trench coat and the divisive blue "IKEA" bag, menswear, Spring/Summer 2017

ABOVE RIGHT Balenciaga raincoat dress with purple "pantashoes", ready-to-wear, Spring 2017

After Wang's departure another potentially left-field appointment got the fashion world all excited. In 2015, Demna Gvasalia, who had founded his cult streetwear brand Vetements with his brother Guram only a year earlier, took over as creative director. In his first year at the helm of Vetements he had become the darling of the fashion world. Some considered Gvasalia an odd choice for Balenciaga and accused the house of being driven more by a desire for cult status and profits than a respect for the brand's heritage. Closer examination, however, shows that although there may have been a sea of difference between the two aesthetically, when it came to business practices, Balenciaga and Gvasalia were aligned in many ways.

Vetements had already adopted several of Balenciaga's own tactics and incorporated them into their own business strategy:

they showed outside the traditional fashion calendar, just as Balenciaga had done, and the distribution of the brand was tightly controlled and limited, to retain control and exclusivity. But, most importantly, this was an anti-fashion stance that was specifically focused on critiquing a consumer culture obsessed with novelty – exactly what the master had eschewed himself.

The show notes to Gvasalia's first collection explained that this was a "reimagining of the work of Cristóbal Balenciaga—a wardrobe of absolute contemporaneity and realism imbued with the attitude of haute couture. A translation, not a reiteration. A new chapter." Classics were reinvented through streetwear and high-end tailoring was combined with hooded sweatshirts.

Gvasalia's reign at the house has seen him reinterpret the archives, and often deconstruct original silhouettes to reveal their complexity and heritage. In 2017, to celebrate the house's

BELOW LEFT
Balenciaga ostrich feather dress, ready-to-wear, Fall/Winter 2017–2018

BELOW RIGHT
Balenciaga ostrich feather dress, 1965

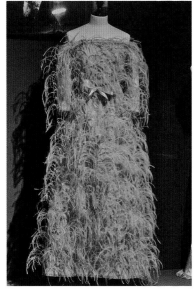

RIGHT Balenciaga
polka dot dress,
ready-to-wear, Fall/
Winter 2017–2018

centenary, Gvasalia created nine spectacular Balenciaga couture dresses that were based on his study of the brand's archive and lookbooks, evidencing not only a deep understanding of the brand's heritage, but also an acknowledgement of the need to modernize and stay relevant.

The summer of 2021 saw the Balenciaga name make a return to the haute couture calendar after a 53-year hiatus, with a collection that was both modern and a clear homage to the master, with references to his original oeuvre through cut, colour palette, embellishments, fabric choices and experiments with draping and volume. While stylistically and commercially things have progressed, developed and changed significantly since 1968, the DNA of Balenciaga's founder nevertheless continues to run through the creations of the new generation of designers, whose work, like Balenciaga himself, still attracts a cult following.

OPPOSITE Balenciaga balloon dress, ready-to-wear, Fall/Winter 2017–2018

ABOVE Balenciaga baby-doll dress, ready-to-wear, Fall/Winter 2017–2018

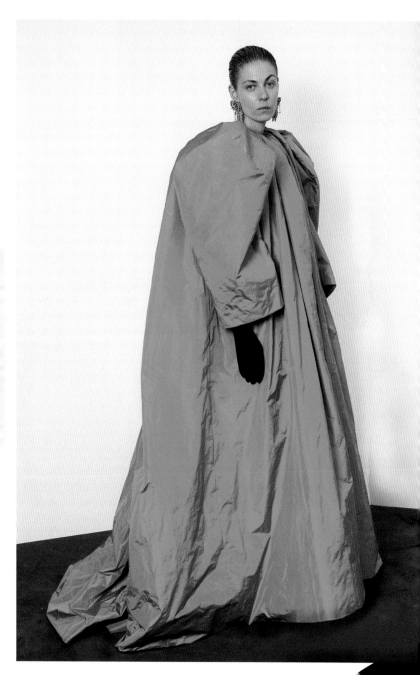

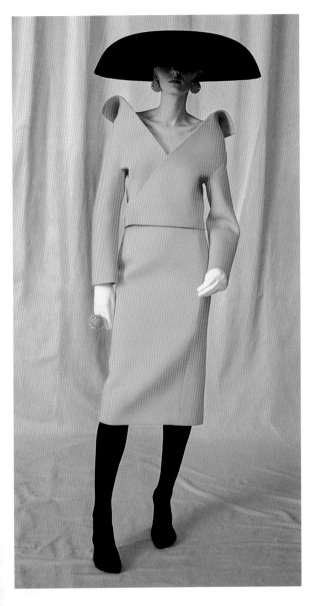

OPPOSITE Balenciaga voluminous emerald green coat, haute couture, Fall 2021

LEFT Balenciaga sculpted orange dress, haute couture, Fall 2021

INDEX

BIBLIOGRAPHY

Arana, Ana Balda. "Cristóbal Balenciaga.
Explorations in Traditional Spanish
Aesthetics." *Costume* 53, no. 2 (2019):
161-185.

Arzalluz, Miren. *Cristobal Balenciaga*. V&A
Publ., 2011.

Miren Arzalluz & Debo Kaat, eds. *Fashion
Game Changers: Reinventing the
20th Century Silhouette*. Bloomsbury
Publishing, 2016.

Balenciaga, C., Jouve, M.A. and Demornex,
J., 1988. *Cristóbal Balenciaga*. Editions du
Regard.

Bolton, Andrew, Barbara Drake Bohem,
Marzia Cataldi Gallo, C. Griffith Mann,
David Morgan, Gianfranco Cardinal
Ravasi, and David Tracy. *Heavenly Bodies:
Fashion and the Catholic Imagination*. Vol.
1. Metropolitan Museum of Art, 2018.

Bowles, Hamish. *Balenciaga and Spain*. Skira,
2011.

Geczy, A., 2013. *Fashion and Orientalism:
Dress, Textiles and Culture from the 17th to
the 21st Century*. A&C Black.

Join-Dieterle, C. ed., 1996. *Japonisme et
mode*. Paris-Musées, Paris.

Martinez de la Pera, Eloy. *Balenciaga and
Spanish Painting*. Fundacion Coleccion
Thyssen-Bornemisza, 2019.

Miller, Lesley Ellis. *Cristóbal Balenciaga*.
Batsford, 1993.

Nicklas, Charlotte. "Tradition and
innovation: Recent Balenciaga
exhibitions." *Fashion Theory* 17, no. 4
(2013): 431–444.

Piancatelli, Chiara, Piergiacomo Mion
Dalle Carbonare, and Manuel Cuadrado-
García. "Balenciaga: The Master of Haute
Couture." In *The Artification of Luxury
Fashion Brands*, pp. 141–162. Palgrave
Pivot, Cham, 2020.

Reponen, Johannes. "BALENCIAGA:
SHAPING FASHION." *Film, Fashion &
Consumption* 6, no. 2 (2017): 165–168.

Rosés Castellsaguer, Sílvia. "Spanish
Couture: In the Shadow of Cristóbal
Balenciaga." *Fashion Theory* (2020): 1–22.

Zeitune, Leonardo Jacques Gammal.
"Popularizing Haute Couture: A
Balenciaga Brand Case Study." *Art and
Design Review* 9, no. 1 (2021): 46–57.

CREDITS

The publishers would like to thank the following sources for their kind permission to reproduce the pictures in this book.

akg-images: 54; Album/Oronoz 93, 99, 150 (right); Les Arts Décoratifs, Paris/Jean Tholance 115

Alamy: incamerastock 58; Anton Oparin 149 (right)

Courtesy the author: 10, 13, 40, 45, 46, 47, 49, 86

© Cristóbal Balenciaga Museum: Getaria_Spain 82, 94

Bridgeman Images: © Brooklyn Museum of Art 60; Chicago History Museum 121

Getty Images: AFP 78, 79, 87, 138-139; Walter Carone 73, 100, 112; Chicago History Museum 62, 63, 66-67, 106, 122-123; Alexis Duclos 145 (right); Estrop 150 (left); Keystone-France 70; Lipnitzki 8; Quim Llenas 134-135; Paul Popper/Popperfoto 57; Pascal Le Segretain 148; Daniel Simon 146; Universal History Archive 65; Victor Virgile 145 (left), 149 (left), 151, 152, 153

Kerry Taylor Auctions: 15, 21, 39, 51, 83, 97, 110, 116, 117, 119, 120, 129, 132, 133

Mary Evans: 22, © Illustrated London News Ltd 25, 31, 33, 109

Shutterstock: Rene Bouet-Willaumez/Condé Nast 27, 36, 42; Henry Clarke/Condé Nast 74, 98, 111, 114; Carl Oscar August Erickson/Condé Nast 18, 90, 102, 103; Horst P Horst/Condé Nast 26, 30, 41, 81; George Hoyningen-Huene/Condé Nast 61; Frances McLaughlin-Gill/Condé Nast 84; Arik Nepo/Condé Nast 32; Cavan Pawson 142; Irving Penn/Condé Nast 126, 130; Robert Randall/Condé Nast 77; John Rawlings/Condé Nast 28; Xinhua 154, 155

Every effort has been made to acknowledge correctly and contact the source and/or copyright holder of each picture and Welbeck apologizes for any unintentional errors or omissions, which will be corrected in future editions of this book.